ENGAGING AS
F*CK

MICHAEL LANGDON

ENGAGING AS F*CK

HOW TO ATTRACT AND CONNECT WITH CUSTOMERS USING VIDEO

►►I

To Stacey, Ferdie and Gloria:

I am in perpetual awe of your talents – thank you for your teachings. You've moulded me into the man I am today and for that I'll be forever grateful. I dedicate this book to you with all my love.

Disclaimer
The material in this publication is of the nature of general comment only, and does not represent professional advice. It is not intended to provide specific guidance for particular circumstances and it should not be relied on as the basis for any decision to take action or not take action on any matter which it covers. Readers should obtain professional advice where appropriate, before making any such decision. To the maximum extent permitted by law, the author and publisher disclaim all responsibility and liability to any person, arising directly or indirectly from any person taking or not taking action based on the information in this publication.

CONTENTS

9. The different types of videos you can create for your business 95

10. How using video gives you more time to work on your business 117

PREFACE

#ENGAGINGASF*CK

'NOW ... WHAT SHOULD I DO WITH HIM?!'

It wasn't until about the third hour of sitting in a Cuban prison, with a Fidel Castro mural towering above me, that I realised I may have taken videography a little too far. I had been detained by Cuban authorities on New Year's Eve. It turns out that bringing a drone into the country was illegal. So was flying it over the streets of Havana.

We'd spent a good week filming in and around Havana, and it wasn't until our last day on the communist island that I had been detained. Luckily for me I spoke Spanish. During my detention, I could hear what the young (and I mean no older than 21!) prison officer was saying to his colleagues over the phone. He had no idea what to do with someone with a drone, and it seemed that nobody else did either.

He had repeated himself a good couple of dozen times: 'Yes, the subject has been identified: a British citizen holidaying on the island. Flights booked back for tomorrow. Now … what should I do with him?!' This went on for hours before somebody called the immigration police in. They came to the police station, and after much more discussion it was decided that I wasn't a threat to national security and I could be released.

The immigration police took us back to our hotel. In the police car on the way back, they told us that Cuba has a huge military parade on the first of January every year, and that I had been flying my drone down some streets that were cordoned off. For all they knew I was a foreign spy! That – apart from making me feel super cool – kind of explained the situation. I'm sure if I had flown a drone over the route of a parade in the UK or Australia, I would have suffered the same fate.

After getting back to my Airbnb house (the owner was not happy to see the police arrive at their house as they were having guests over for their New Year's Eve celebrations) and showing the police my ID, they let me go without charge.

I later realised I had been *really* lucky that evening. Because it had been a public holiday and all the big cheeses were unavailable, this young prison officer – who had been left in charge of Havana's main prison – had no idea what to do with me. He rang countless people but couldn't find anybody who knew how to deal with a drone situation. Without being able to get the help he needed, and knowing that I clearly saw he didn't know what to do with me, he finally let me go. Had it not been New Year's Eve and had the senior officers been in charge, it could have been a completely

different story. Upon landing back in Australia, I found out that a Canadian tourist had been locked up for 14 days in solitary confinement for doing *exactly* the same thing I had done that day in Cuba.

* * *

Choosing a story to begin this book was an arduous task. I wanted to demonstrate how powerful emotions are when telling a story, and how video is the best medium available for eliciting emotions. So let me now tell you about one of the most engaging videos I've ever been involved with: a video review for a Sunbeam electric blanket.

Were you expecting me to tell you about the videos we made while on the Cuba trip? They were great videos. But despite all of the Cuban adventures, the best performing video I've ever been involved with was a review for an electric blanket. It's as simple as that. We made a video review for an electric blanket. It was two minutes long, and it lives on the product page of Appliances Online – Australia's largest appliance online retailer.

What is remarkable about this seemingly ordinary video is the stats behind it! If you were to consider all videos that exist online and rank them in order of how engaging they are, this video would rank in the top 1% or 2% of videos ever made! And it's about an electric blanket. Just in case you still didn't get that … it's about a blanket!

This video has a 94% average engagement record. That means that pretty much every person in the world who watches this video watches the whole thing. To put that into perspective, Vidyard (a leading video agency in America) has reported that only the top

5% of online videos record an average engagement level of 77% or more. This video smashes that figure.

Have a think about what that can mean for your business. A video made about an electric blanket outperformed videos about a trip to Cuba.

So why am I telling you this?

Because emotion comes in all different shapes and sizes. It's subjective, relative, and in so many cases different for so many people. But emotion is what drives storytelling, and storytelling is what allows businesses to connect with their customers. That connection is what will enable your business to thrive and cut through the noise that your competitors are making. That connection will make your business make money. Create a compelling story about an electric blanket and people *will* watch it.

The increasing popularity of emojis to communicate via text shows that pictures are still our preferred method of communication. It almost seems like language is going full circle back to hieroglyphics. That is why video is more important than ever now. Moving pictures are like emojis on steroids! Video keeps proving time and time again that it's *the* most engaging way to consume information online. If you don't believe me, trust Mark Zuckerberg, who recently said, 'in a decade, video will look like as big a shift in the way we share and communicate as mobile has been'.

We are well and truly in the Age of Emotion. In this book I will share some of my knowledge on how to best harness it through the power of video.

'NO-ONE KNOWS WHAT WE DO'

Stevan came to me one day seeking help. He had just sold his company to TripAdvisor, a multi-million-dollar deal that, by anyone's standards, meant Stevan had made it in life! He was still acting CEO after the acquisition, and when I asked him how we could help his business his answer was very clear: 'No-one knows what we do'.

I was staggered by his response. My first thought was, '*Everyone* knows what you do – TripAdvisor just bought you!'

And then it hit me. No matter how big a company is, business owners around the world all have the same problems. We struggle in getting our message some exposure, we have trouble reaching prospects, we tussle to generate leads, to convert those leads and to retain customers.

My line of work allows me to amplify business owners' stories – each and every story compelling and unique. My work brings their brands exposure, it brings about leads who then convert into customers. It generates revenue for them.

Some people say I work in video production; the reality is that it's a lot more than that. I'm in the business of *feelings*. As we move further and further into the Age of Emotion, it is clear that business is conducted from an emotional level. You need people to feel certain things if you want them to act certain ways. If you want prospects, make them feel like you're an industry leader. If you want leads, elicit trust. If you want sales, excite your leads!

This book will show you how to harness all these emotions to benefit your business. And it will focus on doing it through the most powerful medium available to businesses: video.

I will show you the ins and outs of emotive storytelling, and how to start on a DIY video path to make sure your brand connects and engages with as many possible customers as you can.

SO WHO IS THIS MICHAEL LANGDON GUY?

If I expect you to take my advice, it's only fair that I tell you a little bit about myself first. I was born in Hackney, East London, in 1985, and within two weeks I was on a plane to Colombia to meet my dad and my brother. I'd like to think that travelling at such an early age is what spurred my love for travel later in life.

My parents were both teachers and business owners. They owned an English Language school in the centre of Bogota. My mum would run it from 6 am to about 2 pm, and then my dad would do the evening shift, from about 4 pm to 9 pm. During the day, dad taught IT at the school I went to. It was one of, if not *the* best school in the country. I remember the children of the President of Colombia were a couple of years above me at school.

But one day things changed drastically – my ever-loving parents had a big fight. Fast forward two years, and the relationship was over. My brother, who was a young adult by this point, had flown the nest, but I was still a 13-year-old boy who very much relied on my mother. She wanted to leave the country as soon as possible as the break up of the marriage had really affected her, so she asked

me to pick a country to live in! I was torn between going back to England or going to the US, as we had loads of family in Miami.

I chose Miami, and off we went. In hindsight, this is probably where that special bond with my mum began. I really enjoyed my life in Miami, but due to visa restrictions our time there was limited to six months, so we returned to the UK. I went to college in Watford for two years. I then lived in Bournemouth for three years while I studied Multimedia Journalism.

It was during my time at university that I was first introduced to a camera and non-linear editing software. I was besotted with videography from the get-go. I had always loved telling stories, but this emotive and engaging medium pulled at my heart strings in different ways. I felt like I could make the most trivial of things into a Hollywood production (even though when I watch them now the production values leave a hell of a lot to be desired!).

My first foray into videography was making videos for and about my friends. When our football team folded I made an emotional video about us cut to the song *Winds of Change* by The Scorpions. I loved eliciting emotions out of people, and that feeling has carried on through to my professional life.

My first job out of university was as a runner for an online TV channel about the stock market in London. It's funny how I always wanted to do online video, never films or broadcast television. I'd like to think that it's the maverick in me that knew online video production was the way of the future! 😊

After impressing my boss with my running skills, he quickly allowed me to film and edit for the channel. It was all very basic.

One of my favourite parts of the job was every Friday lunchtime when we'd go for a curry. That was my first introduction to long lunches. 'If anyone asks, we were entertaining a client,' my boss would say. My naive self just nodded as I had yet another sip of my Cobra beer.

As I had gained experience in video production, I decided that the time was right to do what I had always wanted to do: travel! One of my best friends and I decided to go to the US to 'work' as football coaches. We saw the whole of the east coast of America while coaching football in the afternoons. That was one of the best years of my life.

I then travelled around South East Asia. I was filming and editing YouTube vlogs of my travels, and they proved very successful. Networks in Australia were paying me ridiculous amounts of cash (ridiculous for a backpacker anyway!) to use my footage. This enabled me to keep travelling. My videos were inspiring people to follow on the journey. Unfortunately, my money ran out and I had to go back to England to work.

I ended up working as a videographer and editor for a company that sent me around the world to film and edit vox pops. They used these videos to showcase market research findings. This was my first 'real' job, and I learned how to hone my filming and editing skills from the people at the company.

Just as I was feeling like I was reaching the end of my learning curve, I got head-hunted by Appliances Online in Australia. One of my friends from university reached out, and before I knew it I was on a plane to Sydney to begin what was another defining period of my life.

Appliances Online wanted to start capitalising on video content. What started out as a man with a handy cam when I got there grew into a fully fledged video production arm, with 12 staff going into the studio to produce 100 product reviews every six weeks.

The data we got from how video increased revenue for the company was mind-blowing (more on this later in the book). It really showed me the positive effect video could have on businesses. All the way from increasing leads to converting them, video meant money!

Five years and a fiancée later, I left the group to start helping small business owners benefit from the incredible power of video. I founded Serious Levity with the help of Stacey, my better half. This is a chapter of my life that has only just begun. So far we have helped dozens of business owners communicate their message in a clearer and more concise way.

It's an exciting time ahead, and I hope this book helps you implement video into your business to help you better communicate and engage with your customers!

Welcome to the Age of Emotion. Let's ride …

1. ATTRACTING AND CONNECTING WITH CUSTOMERS IS ABOUT EMOTION

If you want your business to thrive over the long term, it's vital that you know and understand how and why customers engage with a business and make the decision to purchase a product or service. No matter what your product, service or industry, successful business is about connecting with and engaging with people. A potential customer who you have created genuine engagement with will be much more likely to purchase.

To help you fully understand how purchasing decisions are made, let's have a look at the science behind our emotions and decision-making before we get into how to make awesome videos for your business.

THE SCIENCE BEHIND EMOTION

It was during my last year working at Appliances Online that things became serious in terms of researching *why* customers

purchased from us. In doing so, the business head-hunted one of the world's leading neuroscientists specialising in neuroscientific profiling.

What I learned from her was fascinating. Every day we make approximately 20,000 to 35,000 non-conscious decisions. These range from simple acts such as tying your shoelaces, to opting for tea rather than coffee, to changing gears in the car when you're driving.

Our brain takes in 11 million bits of information every second, but only 40 of these are processed by the cognitive, rational part of our brain: the neocortex. The rest of the information – the other 10-million-plus bits of data – is processed by our limbic system. It processes this information 200 times faster than the rational mind.

Our limbic system is responsible for how we feel and the decisions we make. All this processing, which happens at lightning speeds, works as a filter and tells us whether the factors stimulating us are worth taking notice of, what is relevant to us, and we respond and make decisions accordingly.[1]

Understanding all this brain activity led to neuroscientific profiling. Neuroscientific profiling segments people based on the non-conscious activity of their brain. And, as scientists the world over have concluded that purchasing is based on emotion and not rational thinking, it is the latest scientific development that major companies are relying on to increase sales.

If you're sitting there thinking: 'But hang on a minute, I write a list of pros and cons before a big purchase and rationally decide

1 Katharina Kuehn, 2016. https://thecmoshow.filteredmedia.com.au/neuromarketing-katharina-kuehn/

what I'm going to do through careful consideration – my buying decisions aren't based on emotion', well … the fact is that multiple studies have been carried out that determine the opposite. What you are experiencing is your brain making an excuse for an already-made decision taken by your subconscious mind and based on emotion.

This was the conclusion of leading neuroscientist Michael Gazzaniga after experiments conducted on people with split brains. He calls it the 'interpreter mechanism'. A handful of people in the world have had their brain hemispheres separated to try to cure epileptic fits. These people have become incredibly useful in understanding human brain behaviour. One of the major findings from Gazzaniga was from one of his patients with split brain. He asked the left-hand side of the brain to leave the room, and as the patient was leaving the room, Gazzaniga asked the right side of the brain why he was leaving. The results were remarkable!

The right-hand side of the brain, without being connected to the left side of the brain, started justifying the decision to leave the room: 'I'm going into the house to get a coke.'[2]

That is exactly the same way our rational mind justifies our purchasing behaviour.

What does this mean for business owners?

Little did I know that this steep learning curve on neuroscience would stand me in good stead for when I became a business owner. Not because I was going to use it to sell to prospective

2 https://www.sfn.org/~/media/SfN/Documents/TheHistoryofNeuroscience/Volume%207/c3.ashx.

clients, but because it allowed me to understand how valuable a tool video is for business owners!

If we know that our conscious mind will always justify purchasing decisions to our unconscious mind, then how do we target the subconscious? I have found that through video it is quite easy, and in this book I'm going to share with you what I've learned.

HOW PEOPLE RESPOND TO IMAGES

So now that you understand a bit more about how we all make (and justify) decisions, let's have a look at how people respond to images.

I gave a presentation not too long ago where I tested the Kuleshov Effect on the people who were there to hear my talk. Lev Kuleshov was a Soviet filmmaker. He highlighted this editing technique, which he named after himself. It is a phenomenon where viewers derive meaning from the interaction of sequential shots.

I showed people in the room an image of a man watching something on an iPad, then cut to an image of a hamburger, and then cut to the man smiling. I then asked the audience what they thought of the man. Responses ranged from 'happy' to 'chilling' to 'hungry'.

I then showed another sequence of shots but changed the hamburger to a panning shot of an attractive lady sitting on her own on the beach in her bikini. I again asked the audience what they thought of the man. They burst into uncomfortable laughter: 'He's hungry for something else!' one person shouted. Everyone's opinion of the man had changed to thinking he was a bit of a creep!

This demonstrates how our brain derives meaning depending on a sequence of shots – a perfect example of the Kuleshov Effect and, on a very basic level, how film editors and film makers can play with emotions to elicit a desired effect from viewers.

So if the majority of our purchases are made subconsciously, as we've seen, and you can affect people's emotions using images, then there's no better way to try to communicate your business's value than through video. There is no doubt that video is currently the most emotive way to communicate.

THE IMPORTANCE OF GOOD STORYTELLING

Emotion is everything when it comes to making real connections with people, and the vehicle that drives emotion is storytelling.

The popularity of the internet and the ease and accessibility of recording videos on a mobile phone has seen the internet flooded with videos. The majority of these don't warrant a second's attention, but the reason there are some smartphone videos that get tens of millions of views is that they tell a good story. These videos may be pixelated, framed poorly or lit badly, but if the story connects with you on a personal level then you're going to watch until the very end.

This explains why companies such as LADbible have thrived in the last few years through their video content. According to the *Press Gazette* and Tubular, LADbible was the third most watched media company in the world behind BuzzFeed and Time Warner. If you're familiar with LADbible, you will know that the vast majority of its content is badly shot smartphone footage.

They encourage people to upload videos they have shot on their phones, and (at the time of writing) they pay £100 for every video they use. They do not care for production values, what they care about is a good story that will resonate with their viewers.

The era of disposable video

I believe we're well and truly in the era of disposable video. In my opinion, it's not enough to have one polished video to represent your brand on your website for a few months and then repeat. You need a constant stream of videos to maintain an active engagement with your customers. A lot of small business owners do not have the budget for high-end videos, and that's why I think it's a better strategy to focus on quality messaging than high-production values.

My brother is a high-end video producer – he has worked on videos for companies such as Range Rover and Rolex – and we have had this discussion many times. More often than not we disagree. He sees the value in filming with a better camera, a better microphone and spending more time in post-production to achieve a polished look. I disagree; I think that monetary and time investment would be better spent producing more content that doesn't look as polished.

The funny thing is that both of our ways of approaching this *are* based around storytelling! My brother thinks that those bells and whistles in a video will enhance the storytelling aspect of a video. And I agree. I also think that telling *more* quality stories for the same budget will benefit the business owner more.

So how do you tell a good story?

It wasn't until recently that I realised I was a good storyteller. Not because I doubted my ability, it was simply because I thought everyone had it in them. But the more exposure I had to people from different industries and different walks of life, the more I realised that maybe I did have a gift!

I was always a natural storyteller. I remember entertaining my parents' friends with jokes when they had dinner parties (jokes I didn't even understand until I became an adult!), and loving their reaction when they laughed. It made me feel good to make someone else feel good. And that feeling still carries on today. I would attribute the honing of this skill to two things in my life.

The first one was studying journalism. In studying journalism (and to be more specific, local journalism) they taught us how to make a story out of nothing. And I mean nothing! Back in the day, when you had a deadline to meet to fill up a few columns of newspaper, you had to get a story no matter what. If it was a slow news day you still had to come up with something.

One of the most memorable people in my life was my news lecturer at university, Dan Hogan. He did a really good job of teaching us the knack of getting a story out of nothing. He would do crazy stuff like send us out in the middle of the university campus and tell us we had an hour to write up something newsworthy. It was incredibly difficult. It really pushed you hard to think outside the box. You would be there looking left, right and centre for a story to appear – to no avail. What it pushed you to do was to look not only left, right and centre, but to look diagonally, back, and up. And it was when you looked up at the trees that you

spotted a university lecturer going by the name of Dan Hogan perched on a branch spouting gibberish.

The lesson was simple. There's *always* a story. Even in the most mundane of things. Just find the angle. If you can't find it, look harder – there will always be something interesting to tell about an occurrence.

That lesson has helped me so much in my business. My customers are always impressed at how I tell *their* story. Redefining what they do to find a better angle is something that now comes quite naturally to me, and I really have my journalism background to thank.

The second influence was Helen, my manager at Vox Pops (remember that company that sent me around the world?). She kept correcting my work and making it very evident that the level of work I was producing wasn't at the standard required for the company. In the early weeks of working at that company I remember thinking video production and editing wasn't for me. I took it personally; I thought it was a reflection on my ability as an editor. I was hours away from packing it all in. I felt like everyone thought I was rubbish at my job. It was a horrible feeling. I persevered however, and gradually things got better and I settled nicely at my job, knowing that I was producing some good stuff.

It wasn't until I started my own company and started teaching my junior staff how to edit to our company's standards that I realised I had become Helen! And how much I had learned from Helen. She taught me how to drive a narrative well. Especially when it came to a spoken narrative. It's funny how I had been doing it

for years but it wasn't until 10 years down the line, when *I* had to teach someone else, that I realised I owed a lot to Helen in terms of my ability as an editor. There's an art in driving a narrative, and knowing *why* and *how* to put seemingly innocuous quotes in a certain order.

In my opinion, the verbal narrative of a video is arguably more important than the pictures themselves. That's very important to know when creating video content. If your video contains words, be very careful in the way you structure their order as it will create the flow, feel and vibe in general for your video.

STORYTELLING WITHOUT WORDS

A lot of the videos we produce are images cut to music. These videos can be very powerful as each individual viewer derives their own meaning – you're not forcing a message down their throat but instead letting them generate one from what is meaningful to them. It seems easy enough to put a montage of moving pictures to a song, eh? Well … no. The number of times you see this done poorly is flabbergasting!

One of our biggest partners at my company Serious Levity is The Color Run. The way our partnership started was by us producing a free video for one of their runs. To give you a bit of context, it's a fun run. They throw colour powder at people every kilometre or so, and at the end you have a big colour festival, where people dance, throw colour and generally have tonnes of fun!

We went along to one of these, and shared the video we did with them.

My phone rang at 9 am on Monday morning and it was The Color Run. They wanted to arrange a meeting straight away. To cut a long story short, they wanted us on board as their video partners. According to Tim, one of their directors, we had been able to capture all of the emotive elements that were involved with The Color Run, something other video production houses they had tried had fallen short at.

I was stoked! It was the first major contract I had gained, and it had vindicated my passion for emotion through video. It showed that storytelling through just images was powerful, and also an intricate art to perfect.

It's too easy to fall into the trap of just putting a meaningless sequence of shots to a nice song. A lot of production companies do this and charge a fortune! In chapter 8 I delve further into how to produce and tell these stories well.

We all have a unique and compelling story to tell, especially business owners! It's all about harnessing that story, finding the best possible angle, and making sure you tell it well.

Now that you understand a bit more about how people make decisions and the power of video to connect, in the next few chapters I will show you the ins and outs of video production so that you can tell your story well through the world's most engaging medium and have a real impact on your potential and current customers.

2. VIDEO IS THE MOST EMOTIVE MEDIUM FOR BUSINESSES

There are very few people who would argue against video being the most emotive medium to communicate in. Well-known entrepreneur, author, speaker and internet personality Gary Vaynerchuk calls it 'the number one way to capture the attention of your audience', and I couldn't agree more.

WHY IS VIDEO SO POWERFUL?

So *why* is video so powerful? Remember those 40 million bits of information we take in every second? They are stimulated by video more so than pictures and words. And in this instant-gratification age, people don't want to read. Our time has become too precious. We all have a million things to do every day, and video allows businesses to communicate a lot of information in a short amount

of time. We are now so deeply submerged in an ocean of immediate gratification that even *videos* now have to hook you in within the first five seconds, otherwise you'll keep scrolling until you find something that you like. Platforms such as Facebook and Instagram are driving this consumer behaviour and are forging the watching patterns of future generations.

MONITORING AND MEASURING EMOTIONAL CONNECTION

Later in the book we'll talk about measuring the success of your videos and ROI. We'll also talk about the intangible benefits of video, one of which is emotional connection. But how do you actually monitor and measure emotional connection?

Let's have a look at some great examples of how you can connect with people using the power of video.

$105k to be exact

I always like to use the example of our video *Milly's Story*, which we produced for The Shepherd Centre. The Shepherd Centre is one of our favourite partners. They help children with hearing loss learn to speak and listen through early intervention programmes. We produce a lot of video content for them, as the emotive aspect of video helps them a tremendous amount!

The Shepherd Centre had gathered some footage of a family in Tasmania. It was all very low-quality footage, but the story the family recorded on their smartphones was very poignant. It was

about Milly, one of their daughters who had been born with profound hearing loss. The Shepherd Centre asked me to edit that footage into a quick video as they wanted to show it at a gala event to try to raise funds for the centre.

Milly was a fun five year old! Her family had filmed her singing nursery rhymes, playing hide and seek, brushing her teeth and going to bed. They also filmed themselves talking about the ups and downs of discovering their newborn was deaf, and talking us through the journey they'd had with The Shepherd Centre, all the way through to seeing Milly being on par with her hearing peers by the time she went into school.

I cut all that together to create a powerful video about how The Shepherd Centre provides invaluable support to local communities in Australia. I was quite lucky in that Milly was incredibly charismatic. Everything she said or did was adorable, and it was quite easy for her to make you laugh.

I was delighted with the video when it was complete. I sent it to Robbie who worked at The Shepherd Centre, and wished him luck at his gala event and in raising funds for the centre.

I was gobsmacked at the text I received from Robbie on the night of the gala event:

> That's a hundred-thousand-dollar video, mate! ($105k to be exact.) Legend!

They had started a fundraising auction straight after playing the video (clever!), and *Milly's Story* had pushed bidders to the $105k mark! This simple yet very emotive video had pulled on people's

heart strings enough to generate more than a hundred thousand dollars! It's hard to define other contributing factors to the fundraising success, but there's no doubt that *Milly's Story* played a major part in the success of the event, and this shows the emotive power of video. Video allowed people to visualise exactly where their money was going, and to see how it helps actual human beings.

The 'happiest five kilometres on the planet'

The Color Run pride themselves on being the 'happiest five kilometres on the planet'. And the movies we produce of their runs amplify this emotion. They don't use these movies as promotional videos for their next runs, they use them to highlight the emotion felt on the day, but the brand awareness and engagement they receive using these videos with their customers is phenomenal! Their social media channels are flooded with comments and likes, and people treat The Color Run like a friend and not a company. It's an incredibly clever, genuine way to market your business or charity, and The Color Run do this perfectly by not selling to their customers through these videos.

Putting a face to the brand

Another video example that springs to mind that highlights how emotive video can be was when we started livestreaming on Facebook for Appliances Online. They had a strong Facebook community back then (circa 350,000), however not one Facebook-specific video had been produced.

Together with Katie, the Brand Manager, we decided to tap into Facebook's most recent feature: live streaming. Our first video was a tour around the office, and our social channel went nuts! People from all over Australia were flabbergasted at how many people worked at the company. They were saying it was great to put a face to the excellent service they had received. They were connecting with us!

A free BBQ

Probably the most surprising video in terms of emotive power, though, was a livestream we did at Appliances Online of a competition to win a BBQ. We simply placed a brand new BBQ on a random street in Sydney and said that the first person who found it would win it!

The response was massive. People started tagging their friends, speculating as to where it was. When the location was pretty much confirmed, people were having intense discussions on the livestream as to whether it was worth their boss's wrath if they got caught sneaking out of the office during working hours to go and collect a BBQ that might or might not be there by the time they arrived.

* * *

The engagement and enthusiasm in all of these examples could not have been achieved through any other medium, and they really do showcase the massive power of video. Whether it's building awareness like The Color Run or actual engagement with customers like Appliances Online, video is the best way to create an emotional connection with people.

A lot of business owners, however, want to see a clear, measurable monetary return on investment, and the best example of ROI on emotion from my experience is *Milly's Story*. There was a direct financial outcome linked to playing a video. This also exemplifies what we examined earlier, that people take actions based on emotion and rationalise later.

It makes me feel incredibly proud that I can use my storytelling and emotive powers to help such a good cause like helping young children who are born deaf learn to communicate and speak to the ability of their hearing peers, and if you start to use video you'll be able to experience these effects too.

3. VIDEO GROWTH BY THE NUMBERS

There is a vast array of mind-blowing data about online video. I don't usually doubt the veracity of this information as I've seen the benefits of video first hand, but it can be tricky to track down the study or research that determined such stats. With that in mind, before I delve into other people's findings regarding video, I'll start with some of my own research and findings.

RESEARCH AND FINDINGS

The bulk of my video experience comes from online retail. I have produced over 2000 appliance reviews which have generated more than 15 million views. I was fortunate to work for such an innovative company like Appliances Online in Australia. They invested a lot of time and money into their Research & Development department. The scientists they have working in that

department really are at the forefront of what they do, and they agreed to carry out some scientific research into the effect that videos had on the company.

A 142,000% return

Now this wasn't some basic A/B testing or conversion testing. This was lines and lines of equations with thousands of variables analysed. These variables included things you would only associate with rocket science! These were analysed to determine whether or not having a video on a product page helped the company sell more of that product.

The results were staggering.

For one particular fridge, the data scientists concluded that for every hour of video review watched, the company sold six fridges. That was irrespective of anything else! At the last time of checking that video had sold them 804 fridges retailing at $709. That's over half a million dollars in revenue attributed *solely* to this *one* video! A video that cost approximately $400 to produce. For those who like figures, that's a return of over 142,000%!

I've obviously picked the hero finding of our Research & Development team. Not all videos had that sort of impact, but they did conclude, unequivocally, that having a video on a page increased sales.

Quadrupled conversion rates

My other big finding from my time at Appliances Online was that when a video was placed on a product page it *quadrupled*

conversion rates. The company had a steady conversion rate that was average across all products they sold. We found that when we added a product video review to any product we sold it would, on average, increase the chance of conversion by four times. For example, if 100 people were to land on a page that sold a washing machine, we could expect one sale. If we were to add a video product review for that washing machine, that number would increase to four people purchasing per 100 visits. And this was a site average, which meant some products converted at higher than 4×! Increasing conversion rates is an integral part of any business that wants to increase revenue, and finding how valuable video was to Appliances Online customers helped us in trying to deliver the best possible customer service we could.

80% of internet traffic in 2018

In 2016 we interviewed Kevin Bloch, who is the CTO (Chief Technology Officer) of Cisco in Australia and New Zealand. He told us studies carried out by Cisco had determined that 80% of internet traffic in 2018 would be video traffic. The biggest learning I took out of this was that if a business had not yet harnessed video content then they were really missing out on the huge opportunities it brings!

The second-largest search engine

There's a game I like to play whenever I do public speaking engagements, and that is to ask the audience what the world's biggest search engine is. Everyone obviously correctly guesses Google. The fun begins when I then ask what the world's second-largest search engine is. Everyone offers the usual suspects:

the Bings, the Yahoos, the Altavistas and Lycos (yup, even though I haven't heard of them in over 20 years!). But seldom does someone guess the correct answer. And when I tell them what it is, you can see the whole room have a collective penny-drop moment as to the magnitude and relevance of video.

The answer? YouTube.

YouTube has over one billion users, meaning that almost a third of the internet uses their platform. According to a 2017 *Forbes* article, YouTube mobile consumption has risen by 100% every year. That means that people watching video on their mobile is doubling at unprecedented rates. That goes to show the impact that video is having globally at the palm of our hands. It is no longer reserved for a big-screen experience. And it's not just YouTube that is enjoying this growth; it's evident that Facebook is also embracing this trend, with 100 million hours of videos watched every day![3]

More great numbers

Depending on which marketing company you speak to, they will present you with different data. As previously stated, my experience shows that my videos quadrupled conversion rates. According to Eyeview Digital, including a video on a landing page can increase conversion rates by up to 80%. Marketing software giants HubSpot are also big advocates of video, and they claim that 52% of marketing professionals see video as having the biggest return on investment out of all types of content. They have also

3 https://www.forbes.com/sites/miketempleman/2017/09/06/17-stats-about-video-marketing/#2e8e5b71567f

run experiments which show that after watching a video, 64% of users are more likely to buy a product online.

And the big one from HubSpot, which we ourselves have seen work wonders for our business, is using video in an email. Hub-Spot's studies show that having a video in an email leads to a 200% to 300% increase in click-through rates.

I myself have had a video signature on my email for the last year or so, and the response has been incredible! People approach me at networking events saying they feel as if they already know me. I've also had referrals turn into leads straight from my video signature, with people writing in the comment section of the video that they want to team up and produce video content for their website straight away.

* * *

The world is quickly turning to video to communicate, and videos have a huge opportunity to help business owners. Whether it's to generate more exposure from their business via SEO (Google ranks pages with video content higher) all the way through to conversion, the beauty of video is that – when used properly – it can help solve almost any customer-related problem a company may be experiencing. I've seen it time and time again.

In the next chapter we'll try to determine what problems *your* business may be having (from my experience, most business owners suffer from the same problems, just at different scales) and how to use video to help solve them.

4. HOW TO USE VIDEO TO ATTRACT AND KEEP CUSTOMERS

Videos can help solve most customer-related problems a business may have. It's very important to first have a frank and candid discussion within the business before the production process begins, to determine exactly what problem you are trying to solve. It's crucial to focus on one problem only per video as a single video can't be the saviour of all things.

WHY DO YOU NEED VIDEO FOR *YOUR* BUSINESS?

The problems generally fall into one of four aspects of a business's selling funnel:

- attracting suspects
- educating prospects

- converting leads

- connecting with customers.

Let's have a look at each of these.

Attracting suspects

A 'suspect' is pretty much anyone out there who could use your product, but they are unaware your offering will solve a problem they have. They probably don't even see it as a problem yet!

This is a big category where video can help. Businesses often come to me because they have a great product and/or service but they feel like no-one knows about them. They want to make waves, but are dumbfounded as to why not many people know about them.

The key with suspects is to capture their attention quickly (more so than any other category), and to make the viewer relate to a problem they have – or make them aware that there *is* a problem. Once you have established the problem, the next phase is to answer the questions they have as to how you and/or your product fixes this problem.

Some of the best videos to make for suspects are vlogs (video blogs) and attention-seeking promotional content. The reason why a good *entertaining* vlog (I must emphasise the word entertaining) works is that suspects are more than likely in entertainment mode and not conscious of anyone selling to them. This is where you really target their limbic system. One of my most popular vlogs (in terms of engaging with suspects) was a video I did on tips to film with your iPhone. I had quite a few people

interacting with me and thanking me for sharing my knowledge. I must emphasise that these free video guides I share on my social channels really are done without expecting anything in return. The benefits I get are tremendous though, and I know that I am front of mind for all these strangers should they ever require professional video services.

The beauty of working with businesses and business owners is that they are all experts at something that they do. Just as I'm an expert in filming with an iPhone, a mortgage broker will be an expert in the housing market and could give tips on that, or an electrician could be an expert in lightbulbs and give you tips on your lighting efficiency at home.

In terms of attention-seeking promotional videos, we used to work with Seasoned Music Festival. They came to us when they wanted to grow their brand awareness and reach among young adults in Sydney – a perfect example of targeting suspects. We created a funky, upbeat video of one of their festivals that began with a woman smashing a water balloon in the face of an attractive young man. This video was shared on Facebook thousands of times, and got people tagging hundreds of friends asking if they wanted to go. The video was a huge success in attracting suspects to Seasoned Music.

Another great way to attract suspects is by producing 'frequently asked questions' videos. At Appliances Online we did plenty of these, which we shared on YouTube (the world's second-largest search engine 😊). We were answering questions such as, 'What is an integrated dishwasher?', 'What is a top-load washing machine?' or 'What is a pyrolytic oven?'. YouTube would then

drive traffic back to our website, and often this would result in a purchase if the viewers were based in Australia.

Educating prospects

'Prospects' are aware they have a problem and they are looking at different providers to solve it. This is where a great video can become an invaluable part of your arsenal, as they are great for eliciting trust and guiding prospects further down the funnel.

The key when producing videos for this segment is to give them more in-depth answers and to have a more tailored and specific approach to how you answer their questions. This is also where you specify what your unique selling points are. To use Appliances Online as an example again, it was at this stage we made videos for prospective customers that told them we could match any price found on the internet *plus* we offered free next-day delivery.

We used these videos as pre-roll adverts on YouTube (so viewers had to sit and watch for 15 seconds) for people who were searching 'How to fix my washing machine' and 'How to fix my fridge'. They were clearly prospects as their washing machine or fridge was broken, and when they saw our unique offering, many thought twice about fixing their appliances and instead considered buying a new one! These adverts proved very successful and the click-through rate was huge.

Another successful prospect video we made was a promotional film for EduComply. EduComply is a bit of software that helps schools in NSW stay compliant with all the rules and regulations that govern the safety of children while they are at school. It was

very impactful in that it answered questions and showed multiple problems EduComply could solve (exactly what prospects are after!) in two minutes. It also hooked viewers in from the start as it had a powerful message telling schools what the worst possible outcome was if they didn't follow and implement government procedures.

It is very important to educate, build trust, and position yourself as a leader in your industry when you are producing videos for prospects.

Converting leads

'Leads' are people who have already decided on an offering and just need to know a few more finer details to decide *who* they're going to buy this product/service from.

A lot of marketers think that this is where people are rationalising a purchase, but as scientists have discovered, rationalising comes post-purchase and as a means to justify the emotional plunge our limbic system takes. That's why it's very important to be aware of emotion here too. What feelings do we want to elicit from our customers now that they are so close to purchasing, as it's not a matter of *if* they purchase but *who* they purchase from?

Videos for leads include product reviews, how-to videos that showcase the features of your product/service, and customer testimonials. Videos for leads is where the bulk of our experience comes from. To keep with the theme of videos for Appliances Online (and for you to see the full spectrum of types of videos for one company), this is where we produced over two thousand video reviews for most of the products the company sold.

The most important thing we told our scriptwriters was to ensure the scripts were outcomes and feelings based. Yes, we were selling a dishwasher, but what was it about this dishwasher that was going to make the life of a single father of one a lot easier? We always asked our scriptwriters to relate the video to an everyday living occurrence that would benefit our customers. For example, a dishwasher that had a 'half-load' function would mean that Dad could buy that large dishwasher for when he was entertaining but wouldn't waste too much water and electricity if he used the half-load function when it was just him and his little one every other weekend. That sort of visualisation and emotion would help our leads turn into customers.

Another example could be the 'delay' function on a washing machine. Our scriptwriters were very adept at not just highlighting the fact that it existed, but on focusing on how that tiny little button could make your life so much more convenient! If you had to rush out to the office at 8 am, you'd simply delay the end of your washing until you got home. That would essentially mean the washer would do the washing while you were at work, and finish as you were walking through the door just in time to hang it up. No damp, smelly clothes because they'd been sitting wet at the bottom of the drum all day – surely everyone hates damp, smelly clothes!

We have a lot of customers who come to us and tell us they are happy with the traffic they are attracting but lack conversion power. Arguably this is the best asset of online video. One of the best ways to convert is to produce customer testimonial videos. Your customers, more often than not, are *a lot* better at communicating the problem your other customers are having. And once

you've delighted them, they will become your biggest marketing tool.

These videos are quite easy to produce too – all it takes is asking them how happy they were with your service and whether they would recommend you and why. If you have given them a remarkable service you'll be surprised at how long they can praise you for.

These videos have to be genuine. Don't ever fall into the trap of getting an actor to stage these. People are too savvy nowadays, and it will actually be detrimental to your brand if they see right through you. Seeing (and hearing) someone who was previously in their shoes explain how your product has made their life better is probably your biggest marketing tool and a sure way to convert leads into customers.

Another great way to convert leads into customers is to record live webinars that showcase your expertise. The two most popular webinar recording platforms are gotomeeting.com and zoom.us. Try these if you have a great idea for a webinar and enough people interested to watch it. Some of my customers think they would not get enough people to join them live for a webinar and are consequently put off doing one. Remember that these webinars are there to live forever. You can distribute them after doing the webinar, so their shelf life is not limited to whoever is watching live. A very popular tactic among some of our customers is to repurpose their webinars into short videos of all the different topics they cover. These sometimes prove to be more successful when uploaded to YouTube than when delivered live. Webinars are an incredible tool to demonstrate you're a leader in your field and are mighty at converting leads into customers.

Connecting with customers

'Customers' are people who have already bought from you. You may think that videos for this segment are futile, but in actual fact some of our best results have come from videos we have produced for customers.

The problem some of our customers have is that they are not generating enough repeat business from existing clientele. They also feel they are not achieving the connection and brand loyalty they would expect from their clientele. Luckily for them, video is all about connection!

At Appliances Online, we used to get the CEO (bear in mind this is a big company with 500-plus staff) to record personalised video messages for customers when he just wanted to say 'thanks for shopping with us'. These videos proved to be great PR, as the word of mouth about the legendary service they received (which even included a personalised thank you video from the CEO!) would start doing the rounds on social media.

We even used these types of videos to communicate with our customers when things didn't go so well. There was an occasion when a few hundred customers were not going to get a delivery they were promised. It was a big mess up on our behalf and we were truly sorry. We knew a simple email was just not going to cut it, so we decided to record a video apology from the CEO. Although we did receive some backlash from customers, there was a large proportion of people who appreciated the apology and the fact that the CEO himself had taken the time to connect with the customers who had been let down by the delayed delivery.

It seemed that, despite our stuff up, people were appreciative of the personal touch to the apology that only a video can bring.

The most successful video for existing customers of Appliances Online was the livestreaming series we produced for the company's eleventh birthday. We had tens of thousands of views every day, and hundreds of daily shares on Facebook. We had well and truly managed to connect with our existing client base.

We were giving away prizes (which helped a lot!), but more importantly we had hundreds of our existing customers tuning in every morning at 11 am to engage with us live. Every customer that we spoke to on the phone would sing our praises and tell us they were delighted with the service we were giving them and that they would be our customers for life. This was, of course, a culmination of all areas of the business delivering a great experience, but the video content and platform we were providing to them to communicate with us was the icing on the cake. You could tell they really felt valued.

Another great way to use video with existing customers is to communicate new product launches with them. They will feel special that they are first to know about the product, and this will cement their brand loyalty.

At the time of writing we are working with one of our partners on a training video for their new software. They have released the software to their customer base but it hasn't really been picked up. Our partner feels frustrated because they *know* their product will save their customers time and money. Producing a short promotional video highlighting all the key points of the software will whet their customers' appetite and generate interest. The

two-pronged attack will be finished off with a longer in-depth training video on each feature of the software.

Our experience shows us that this will solve our partner's concerns as their clients will feel both excited *and* comfortable using the software, and that in turn will increase the uptake of their software.

* * *

I have hopefully demonstrated in this chapter that video can be an invaluable asset at any point of your customers' purchasing journey. If used correctly, be prepared for growth.

Now that you know *what* problems video can solve, in the next few chapters I'm going to delve into the technical aspects of *how* to produce videos.

5. HOW TO PRODUCE GREAT VIDEOS FOR YOUR BUSINESS

Video production can be a very complex and meticulous process. You would be surprised at the amount of time one can spend working on a five-second sequence (sometimes months!). For the purpose of this chapter though, I will break the basics down into three main points that you must get right if you want to produce a decent video:

- an engaging story
- great appearance
- clear sound.

If you get these basics right, producing videos for your business will become quite easy. Let's take a look at each.

AN ENGAGING STORY

The single most important thing to determine is your story. Without a story you have nothing. The first question you've got to ask

yourself is *what* is your message? What do you want people to take from this video? Try to keep it to one key message (two at a push!). You can't be all things to all people, and likewise a video can't answer all questions for all people.

Once you know what your message is then you can start thinking about *how* you are going to communicate it. Will it be through animation? Will it be filmed? Will you use actors, or appear in it yourself? (I will explain the pros and cons of these in the next few chapters.)

This is a great time to think about the 'hook'. By hook I mean, how are you going to make this video different to all the other videos that exist about the same topic? I recently filmed at a fast-food burger joint and the owner couldn't quite express what was different about his unassuming restaurant. After putting the camera down for five minutes and just having a casual talk, I discovered that he made his own ice cream *and* that his restaurant was Deliveroo's most popular restaurant in the local community. Bang! Straight away we had two great hooks to market his restaurant with and get great accompanying shots for. We chased down the first Deliveroo person we could find and asked him to give us an impromptu Oscar-deserving performance in front of the camera. He didn't know what on earth was going on!

GREAT APPEARANCE

The second most important thing to pay attention to is to make sure your video looks good. Don't confuse this with high production values. With the technology available on our smartphones

there's no reason why all videos shouldn't look good. You can film beautiful high-definition videos easily on a smartphone nowadays.

Things to look out for in terms of looks are the obvious ones. Don't film in dark places. Make sure you pick a bright spot. If you or your subjects look dark and pixelated people will disengage and switch off.

The most common mistake I see is people filming in an office with a window behind the person being filmed. The brightness of the light coming in through the window means they look like a shadow or silhouette. A lot of people think that the answer is to expose for the face and then just have a really bright white, overexposed window behind them. That looks pretty bad too, and the solution is actually a lot easier! Simply film the other way – with the window in front of the person being filmed, rather than behind. Use the natural light coming through the window to light the subject's face. If you're doing this with a hand-held mobile device, simply position it between the window and the subject and you should be good.

In terms of composition, it's always good to position your subject in the middle of the frame. This is especially true if you're doing a talking head piece that is straight to camera. A lot of cameras allow you to divide the frame equally into three vertical columns and three horizontal rows. These lines show up only on the view-finder as a reference, and won't be burned onto the actual video itself. If you're doing talking heads, it's always wise to position your subject in the middle column and have his or her eyes on the upper row. Always ensure that you leave a *little* head room on top of the frame, the emphasis being on *little*. (This is if you're fram-ing someone in the middle of the frame; for example, if you're

delivering a piece straight to camera. If you're framing for a tradi-
tional interview then the 'rule of thirds' applies – see page 77. You
would frame someone for an interview when you want to portray
them as an authority or for more traditional corporate videos.)

In terms of clothing, it's always good to wear block colours. If you
know your background is going to be dark, I always tell my talent
to wear something bright so they stand out. The opposite also
applies – if you know the background is going to be light, wear
dark clothes. I would stay away from stripes, checks and floral
patterns on clothes as they tend to create a moiré effect. A moiré
effect is that optical illusion you sometimes see on your screens
where the lines of the checks and stripes seem to be wiggling.
Camera technology (and really, knowing your theory in terms
of frame rates to shoot at, and other techniques) can eliminate
this, but it's always better to be safe than sorry. So, stay away from
them altogether. On a personal note, I'm not a big fan of huge
logos being on display, unless of course it's a fashion shoot for that
specific brand.

Deciding whether to shoot inside or outside is a very difficult call.
The easy option is always to shoot inside. This is because you can
control a lot more things inside than you can outside. Examples
of outside issues I've encountered over the last decade include:
wind, rain, tooting cars, passers by pulling faces at the camera,
buskers playing music, and the sun being in an awkward posi-
tion in relation to what I want to film. The benefit of shooting
outside is that it can give you a beautiful backdrop, but I would
always make sure I do a 'recce' (industry slang for reconnaissance
mission) of the location before I shoot, to pre-empt any issues.

If you decide to shoot indoors, you're almost always in control of sound and lighting so the shoot tends to be easier, and more cost-effective if you haven't rented out a studio. The downside of shooting inside is that backdrops tend to be quite bland and uninspiring.

CLEAR SOUND

Sound is the most underrated aspect of video production for those who are not in the industry. People tend to take it for granted. For those who *are* in the industry, it is a crucial, pivotal, game-changing essential. If you make viewers struggle to hear your story, no matter how great a story it is they will eventually get tired of the effort they are making and switch off.

I would never recommend recording audio straight from your phone because it is simply not good enough. Invest in a lapel microphone for your smartphone if you're going to choose to produce DIY videos for your business. If you can't afford a lapel mic then the last resort is using the headphone cable's microphone.

We have been known to spend whole days doing sound engineering for videos that are only two minutes in length. And I'm not talking about laying a song underneath a video. I'm talking about the tiny sound effects; the ones that stimulate one's viewing experience and give videos meaning that they wouldn't otherwise have without any sound effects.

The easiest way to describe this in writing is the following: imagine you had an animation with two computer monitors on screen. New information keeps popping up on each monitor, but your

viewers are missing this because their attention is elsewhere on the screen. Do you know what's going to drive their attention directly to the monitor on the right-hand side? A simple and subtle 'beep'. Simply put a 'beep' as soon as new text appears on the right-hand side monitor and – like a guided missile – your audience's eyes will go there. And if you want to subtly direct their attention to the left monitor, add a simple 'ding' when new text comes up on the left monitor.

These simple sound techniques will have your viewers in the palm of your hand in terms of where you want to pinpoint their focus. You could even have a bit of fun and have their gaze replicate a game of tennis!

Always remember to put as much effort into the audio you are recording as you do into the images you capture; it is equally important.

* * *

Now, let's get to the nitty gritty of video production and how to start the process to ensure you get the best possible videos you can.

6. PRE-PRODUCTION BASICS

The answer here is simple, and I'm going to state it three times to make sure it sinks in: PLAN, PLAN and PLAN. In over a decade of producing online video content I have seen a direct and irrefutable correlation between the amount of effort I put into the pre-production and planning of a video and the quality and success of the final piece.

This in turn also leads to the videos being timeless. There are videos I produced over five years ago that I still show prospects or include in my showreel today because the time we spent in pre-production means the quality still stands tall compared to the advances of the last few years (both personal and technological). Trust me, the more thought you give to *everything* in pre-production, the better your videos will be.

Here are some of the things you should take into account …

YOUR MESSAGE

Why are you producing this video? *What* is the message you're sending? These are the two most important questions to answer as soon as you sit down to pre-produce. Remember to stick to the one (two maximum!) messages you want to relay.

YOUR MEASURE OF SUCCESS

How are you going to tell whether this video was a solid investment? Well-produced videos will always give you a return, although not always an immediately obvious monetary one. Videos should be produced to help you in an area where you are struggling, so ask yourself how you're going to measure the success of the video and whether it solved your problem.

If it's connecting with suspects then the number of views it has will be a good metric. If it's engaging with prospects then use the 'average engagement metric' to see how well you have done. Vidyard (a reputable video hosting platform) states that the top 5% of videos retain viewers to the last second. (Our attention span is low when it comes to videos too!)

From my experience in producing over 3000 videos, I would use this basic table as a gauge to measure how engaging your videos are. (See chapter 12 for more on this.)

Average amount of video viewed	Result
<50%	Something didn't go well
50%–60%	You did okay
60%–70%	You did well
70%–85%	You did superbly
>85%	You did a phenomenal job!

If you want to measure conversion rates then either put a button on the video itself and track how many people click on it, or if you link your Google Analytics account to your Wistia account you can create segments to compare conversion rates and bounce rates between people who watch videos against those who don't. That will be an easy way to determine whether your video is working for you or not. Bounce rate, for those unfamiliar with the term, is the percentage of people who navigate away from a page as soon as they land on it.

There are plenty of different measures of success, which I will talk about in more detail in chapter 12. But make sure you're asking yourself these questions in the pre-production stages, otherwise you will be heading in the wrong direction from day one.

YOUR BUDGET

Once you have figured out your measure of success, you should move onto your budget – they are directly linked. If your average sale order is $10,000 and you're producing a video for leads then

a safe investment would be to spend 5% of that to convert a lead. The beauty of a video is that it can be used many times, so if your measure of success is to convert at least five leads into customers from that video, your budget would be $2500. Anything over five leads converted and you're starting to see a return on your investment.

It is at this stage you also start to think about how polished you want your video to look. Remember that a shoddy production will be detrimental to your brand. If viewers see an amateurish production they will think that your service or product is also amateurish.

The proliferation of DSLRs (high-quality still cameras that can also produce video) in the videography space has really driven down production costs recently. On the following page is a rough guide on what you should expect to pay and the quality you will get.

VIDEO STYLE

Style is an obvious decision to make in pre-production, but a lot of the time it is taken in haste or without due consideration.

The two main styles are animation and real footage. I always recommend, where possible, using real footage. This is because I think humans connect better with actual human beings rather than sketched humans and other illustrations.

	Cost*	Quality of production
One-person videographer	$1000 to $1500	• Not much pre-production. • Decent quality but lacks the finer details. • The cuts are basic and sometimes even amateurish. • You will be lucky to find a good storyteller – they are usually people with a strong passion for the aesthetic element of filming. • Graphics are usually not their strong point at all, and may actually bring the quality of the whole production down.
Small production house	$1500 to $6000	• Good pre-production process and good quality of storytelling. • Great shots and intricately cut. • Polished effects and graphics look elegant.
Large agency	$6000 plus	• If you're paying over $6000 for a two-minute video then you should really expect something extraordinary. • You should start seeing productions that look a lot more like what you see in the cinema. • You should receive talking actors, great transitions, really clever stories, beautiful shots and great colours.

* Based on 2018 prices and a two-minute video.

You should also take into account what shots you want to get, where you want to get them, and whether it's cheaper to have a camera crew capture them or whether you can buy them from a stock footage website. Unless it's something specific to a person or a remote place, there really isn't much you cannot find on stock footage websites. istockphoto.com, shutterstock.com and dreamstime.com are some of the most popular stock footage websites, but they tend to be expensive and/or sign you up for big amounts of money when you only need one shot. I personally use videohive.net a lot as it strikes the right balance between quality and value for money.

Animation is obviously a very powerful tool when your subject matter is slightly obscure or when filming will just not be good enough for what you're trying to do. For example, when producing videos about software, animation is usually the best bet as you can bring to life something that ordinarily just sits on a screen. Animation is also a good option to use if filming proves too expensive. For example, if you are a start-up company with software that will revolutionise the pharmaceutical industry, but you haven't yet got the budget big pharmaceuticals have, then it may be too expensive to re-enact a scenario in a hospital where two doctors and five nurses are following the correct procedure in your new software that helps with administering the precise doses on a large scale. In that case, an animation would be the obvious choice!

VIDEO TONE

The tone of the video is a very important element of pre-production, and is an aspect of your video you should always revert to. Do you want to leave your viewers feeling inspired, happy, in awe, anxious? Decide on the feeling and make sure the rest of your pre-production process sticks to that. A basic element of story-telling is to take your viewers on a journey, so maybe start with a tone of angst to connect with a problem your customers may be having, but leave them in awe of your product. If you're writing a script (we will talk about that in a later chapter), make sure all language and shots reflect the tone you've set for your video.

It's very easy to sway from tone to tone, so remember to try to stick to one or two.

VIDEO LENGTH

Probably *the* question I get asked most is 'How long should my video be?' Wistia (a video hosting platform like YouTube but aimed at business owners) has kindly answered this for us by analysing the performance of hundreds of thousands of videos. They concluded that the sweet spot for optimal engagement is two minutes. After that, people start clicking away from your video.

Length is very important as it is intrinsically linked to engagement. You need to get your message out succinctly and make a splash from the word go. Anything over two minutes will likely bore your audience. The exceptions are educational pieces or pieces of content people have paid for; people can remain engaged with these videos for seven to ten minutes.

If your video is for social media, I would recommend it being less than 60 seconds. Instagram doesn't currently accept anything longer, and, unless your content is gold, you're likely to lose people's attention on Facebook if it's any longer than that.

CHOOSING THE MUSIC

Where possible, I like to choose my music in the pre-production stages of a video. Going into a shoot knowing what song you are going to use means you get shots related to the song, which can lift a video immensely. This is especially true when producing movies of events, for example. If you know that your final video is going to be cut to one song and there's no dialogue then I would try to source the music before I go into the shoot. There are two main reasons for this:

- Music is going to be the biggest, most powerful ingredient in the recipe that is your final video. It will generate most of the emotion for the piece and prompt your viewers to feel exactly how you want them to feel.

- Music usually takes a long time to source. Finding that perfect song is very time consuming. (See opposite for a very common meme among videographers.)

More often than not, however, it is quite hard to choose a song in pre-production as the majority of videos are going to be driven by dialogue and quotes you acquire during the production process. We will cover that topic in chapter 8.

Time spent editing

Actual editing

Finding the right song

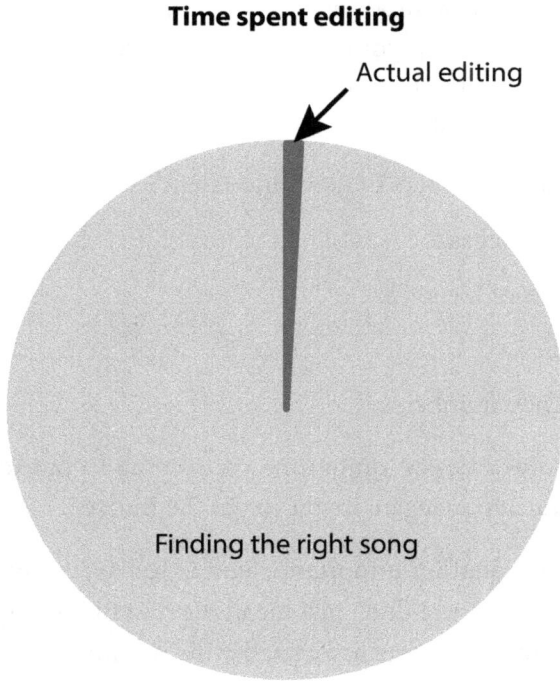

PRE-PRODUCTION ADMIN

Before we move onto the fun part of the pre-production process, it's worth mentioning the administrative tasks of pre-production.

Location scouting is very important. As the name suggests, this is where you 'test drive' different locations to see which one is going to best suit your production. Although these are better done in person, you could potentially location scout through pictures on the internet. But once you have chosen the location online, you should definitely undergo a reconnaissance mission to make sure you'll have no surprises come shoot day.

Run sheets are very important as they minimise potential problems occurring during your shoot. A run sheet is quite simply a sheet of paper detailing the most important bits of information with regards to the shoot. These include:

- names and numbers of crew and talent

- weather forecasts

- addresses of locations

- schedules

- emergency numbers.

They can sometimes be quite time consuming to put together so it's a good idea to delegate if you've got the budget.

Your budget is another important element to have in mind during pre-production. And I don't just mean the cost of filming and editing. There are other costs associated with production. One of the most common ones is consumables while filming. It's quite common in the TV and video industry to provide lunch and snacks for talent and crew. It is not required under Australian law to provide the food but it's regarded as good etiquette in the industry. Other costs associated with shoots can include batteries, tape, hair and make-up artists, and much more. Make sure that you've liaised with the necessary people involved on whether these costs are included in the filming or whether they will be additional.

Lastly in terms of the admin side of pre-production is getting the props. Depending on what you are shooting, this could include a teddy bear, or a suitcase, or a chair, or maybe an iPhone to

showcase the software you are featuring. It could be anything! Make sure you have a checklist with all the props you will need and tick it all off before the shoot.

THE STORYBOARD

A storyboard should be the most important task of pre-production. Planning your shots and their sequence in advance will bring all your ideas to life and really help you visualise what your video will look like. This will be useful for both filming and editing. It will also show you what is definitely *not* going to work, saving you time and money in the production process.

A storyboard is a visual representation of each scene in your video. They can be rough sketches or very elaborate, and usually include the camera angle, the action in the scene and a brief description of the scene. Storyboards can be simple sketches on an A4 sheet of paper or you can download templates from the internet that break shots down into the visual and spoken elements of each scene. It is in the storyboard where you can really start sketching what camera angles, transitions, and wording will work well with your video. I usually do them in pencil as it's a process that fluctuates a lot from idea to idea, so it's easier to rub something off than to start again with a blank sheet of paper. On the following page is an example of a template you can use to create your storyboard, with a new box for each scene.

Scene:	Frame:

Sound:	Script:
Time:	

Scene:	Frame:

Sound:	Script:
Time:	

Scene:	Frame:

Sound:	Script:
Time:	

Scene:	Frame:

Sound:	Script:
Time:	

* * *

Once you are happy with all your pre-production planning, and most importantly with your storyboard, it's on to the exciting part: the actual production process!

7. PRODUCTION BASICS

WRITING THE SCRIPT

The first thing you will probably find yourself doing in the production process is writing the script. This is the first time you will put your tone, style and messaging into action.

The key points to remember when scriptwriting are:

- Hook your viewers in from the start. Remember that you are telling a story; it needs to be emotive! You ought to focus on creating an immediate connection with your viewers. You should also clearly explain the problem you are trying to solve.

- One of the most frequent mistakes in scriptwriting is the inclusion of jargon. Avoid terms that only people in your industry will know. If a viewer simply doesn't understand the language in your video, you will lose them.

- You don't want your script to sound too much like a sales pitch. Keep the language conversational. Write in short sentences. Use simple language; don't fall into the trap of thinking that big words will make you sound clever. The acronym KISS jumps to mind here more so than in any other part of the production process: *Keep it Simple, Stupid.*

- When you have decided what the key message of your script is, remember to lead with it from the get-go as there will be a fair few people who won't make it to the end of your video.

- Once you have decided on the length of your video, remember to write a script that matches that length. As a rule of thumb, humans speak at a speed of roughly 2.5 words per second. If you want your video to be two minutes in length then you should be aiming for a 300-word script.

CHOOSING AND SETTING UP THE LIGHTING

I cannot overstate the importance of good lighting. And this doesn't mean encouraging business owners to spend thousands of dollars on professional lighting kits for their one-off productions. It simply means being aware of lighting and how to best position yourself and your camera depending on the lighting you find yourself shooting in.

The 'three-point lighting technique'

The most basic technique in lighting, especially when filming interviews, is the 'three-point lighting technique' (shown on the following page). You have a key light that is the main light,

which illuminates the subject's face, then a fill light coming in at a 45-degree angle from the key light. This one, as the name suggests, fills in the few shadows caused by the key light. Then you have the back light. As the name suggests, it usually lights the back of the subject – I usually place it directly opposite my key light.

If you don't have a professional lighting kit, try to remember these three lights and use natural light sources at your disposal to try to recreate this as much as you can.

Back light

Subject

Interviewer

Fill light **Camera** **Key light**

Shooting inside

A lot of business owners will find themselves filming in their office. The most important thing to remember if you're filming in your office is to use windows as your key light. Windows are a great light source and should always be put in front of the subject. If you place them behind a subject they will act as really powerful back lights and completely overexpose your shots, leaving the subject in the shadows and looking like a silhouette.

Shooting outside

If your office is really dark and lacks big windows, it's usually best to film outside during the day. This is because you will be guaranteed good lighting even on a cloudy day. Now, there are hundreds of things to take into account with lighting and filming in relation to the sun, but the three-point lighting technique should help you tackle lighting issues as best as you can.

Avoiding hot spots and shadows

A big mistake people often make with lighting (and I was guilty of this in my early days) is to throw too much light on a subject to avoid them being dark. While in theory this is correct, I heavily recommend you invest in a diffuser or a soft box. This essentially softens the impact of the light hitting your subject, and gives them a nice, even glow as opposed to bright, greasy hot spots.

Another big issue when amateurs use lighting kits is they are oblivious to the shadows that are cast, both on the subject's face

and other walls behind where they are shooting. Make sure you are aware of these, and that you adjust your set up to minimise or eliminate them.

To stop shadows forming on the wall behind the subject, make sure there's enough gap between the subject and the wall behind them. Another easy solution is to dim the light slightly.

I've been in situations where there's not enough room to separate the subject from the wall, so the best solution is to crank up the light to its maximum beam and aim it at the ceiling. The light will bounce back from the ceiling and light the room *and* the subject evenly and beautifully. This is my go-to tactic every time I'm filming somewhere with low ceilings.

And don't ever shoot under spotlights as these create shadows under the subject's eyes and make the subject look like a raccoon!

Colour temperature

Another thing to bear in mind when shooting indoors is the colour temperature. I'm not going to go into the theory, but the majority of the time you will find yourself in rooms either lit by tungsten bulbs (orange glow) or daylight bulbs (white glow). If the room you are in has tungsten lighting then use your tungsten light. Don't mix the colour temperatures as you will have a nightmare in post-production, and the lighting will more than likely always look slightly off (unless you get a professional colour grader in, and they cost quite a bit).

CHOOSING AND SETTING UP THE CAMERA

The camera you choose to use will usually be determined by your budget. Video-specific cameras are still generally expensive – you're looking at $6000 to $60,000, depending on the quality and the make. The beauty of the proliferation of DSLRs is that it is now more affordable than ever to get great-quality content for a fraction of what it cost 10 years ago.

Canon arguably pioneered this shift from traditional video cameras to using DSLRs with their release of the 7D and 5D. In my opinion, they led the way for a good 10 years in video DSLRs, until Panasonic and Sony surpassed them with the GH5 and A7S respectively. If you were to invest in a DSLR for your business I would recommend either of these two cameras. They should cost around the $2500 mark.

These cameras will allow you to film up to 4k (ultra high definition), and they will even do high frame rates (slow-motion shots) in 4k, so the quality really is outstanding. The beauty of these cameras is they are compact and easy to carry, portable enough to go from location to location in and around a business owner's company.

Another big consideration for business owners, especially if they plan on doing many vlog-style videos for their business, is whether the camera has a flip LED screen. That is very important if you want to see how the shot is framed when standing or sitting in front of the camera.

You should also consider what automatic and manual settings the camera has. Back in the day, when I was training as a camera operator, the biggest lesson they taught us was to have every

setting on manual. That way you can be in charge and in control of any variable. This was especially true of the focus feature. It encouraged you to make sure you always focused before a shot, and that the focus was pin-point accurate.

Fast forward 10 years and technology is starting to make me doubt whether this should *always* be the case. There are a lot of cameras out in the market with great automatic focusing capabilities. This is great if you plan to set the camera on a tripod and have no-one operating the camera. You can simply walk around the frame confident that it will always keep you in focus. Again, great for one-man bands and business owners alike.

The lenses

The camera is only half of your arsenal though. What is really going to determine the look and feel of your footage is the glass at the end of the camera, so make sure you invest in a good lens. Arguably more important than the camera itself, your lenses will be a big investment.

Focal length

There are tonnes of factors to take into account when choosing a lens. The main one is the focal length. Depending on how far away from the camera your subject will be, you will choose a different focal length lens. For example, if you're shooting a speaker at a conference where you have to place the camera behind the crowd then you would use a high-focal-length lens. If you are shooting a real estate video in a really small room but you want to get as much of the room in as possible then you would use a really

low focal length to get as much of the room in and make it look huge! Focal lengths are measured in millimetres.

Lens aperture

The second big consideration is the aperture or f-stop of the lens. This essentially means how much light the lens lets in. The lower the f-stop, the more light it will let in. This means it will be great for shooting in low-light conditions, and also great for giving you a shallow depth of field. By shallow depth of field I mean that nice cinematic look where the subject that you're shooting is in sharp focus but everything else is blurred. This really makes your subject stand out, and gives the rest of your image a soft look.

You can get lenses that are called 'prime lenses'. This means that they only have one focal length, and these are usually better quality with lower f-stops. However, for business owners I usually recommend a lens with some flexibility to cater for different needs that may arise. A 24–70 mm lens usually is good enough for most needs.

Lens stabilisation

Technology advancements have not been limited to cameras; nowadays lenses carry an incredible amount of technology too, so much so that recently my decision-making on lens purchasing has taken on a new aspect to consider, and that is lens stabilisation. What this means is that the lens itself stabilises your shot, so if you're shooting someone while you're walking, the image isn't going to look too shaky. Sometimes these stabilisations only work with lenses of the same brand as your camera, so it's important to look out for compatibility.

Gimbals

We have recently seen a lot of gimbals become available to help with the stabilisation of shots. Gimbals are a motorised bit of equipment that stabilises camera movement (see image below). They usually stabilise the camera on three axes: the pan (side to side), the tilt (up and down) and the roll (diagonally across). In stabilising the camera, gimbals make shots look more cinematic. The Ronin-M took the market by storm from about 2013, but now we are seeing the likes of the Zhiyun Crane deliver just as good results but at a fraction of the cost and size. The fact that it's so small means that lens weight is now also a consideration if you're looking to use your lens on a light-weight gimbal. There are some great lenses that weigh a good couple of kilos and they may be too heavy for your gimbal to take.

BEFORE YOU PRESS 'RECORD'

The two most important aspects to look out for before you actually start the camera rolling are that your shot is in focus and that it's correctly exposed (not too dark and not too bright).

Getting focused

When filming a person I usually focus in on their eyes and make sure they are in focus. This is easily done when you are using artificial lighting as it gives their eyes a glint. I focus in on that glint and make sure it's as crisp as possible. Whether it's a person or any other subject you are filming, it is best practice to artificially 'amplify' the image in your viewfinder and make sure the subject you are filming is nice and crisp. Most DSLRs have a button to amplify the viewfinder image. Don't confuse this with actually zooming in with your lens, as that will change the point of focus.

Adjusting the exposure

Once your subject is in focus, the last thing you do before you hit that record button is to make sure the image is correctly exposed. And you've got four levers to play with to adjust the exposure.

Adjusting the aperture

The first one is the aperture or f-stop. This is how much you open up the lens to allow it to let light in. The lower the f-stop the more light you will let in. The main benefit of this is your image will have a shallow depth of field and gain that cinematic look. The main disadvantage is that you run the risk of the subject going out of focus. This is especially true if you use it for an interview and

the person shifts around during the interview or sways back and forth when talking. If the camera is not manned and you are using it to capture an interview, I would never go below f 2.8. This again is because if the subject sways slightly while we are interviewing, anything under f 2.8 would mean that the risk of the subject being out of focus is greatly increased!

Adjusting the shutter speed

The second lever is the shutter speed. This is (trying to put it as simply as possible) how quickly your camera lets light in. It is measured in hundredths of a second. If you are shooting in 25 frames per second (which is called PAL, and it's the system mostly used in the UK and Australia) then you ideally want to be shooting at 1/50 shutter speed. This means that each time the lens opens to capture light, it is open for 1/50th of a second.

There are many pros and cons to deciding what shutter speed you use, and a lot of theory behind it. For the sake of simplicity, I'll tell you what I mostly do and why. Ideally I try to double the shutter speed compared to the frame rate I'm shooting at, so if I'm shooting at 50 frames per second, I'll shoot with a shutter speed of 1/100. This gives the most natural look. By natural I mean what the human eye is used to seeing in cinemas and on TV.

An important thing to consider when choosing your shutter speed is if you are filming in a place that has a TV or some sort of monitor in the shot. Have you ever seen a TV or monitor in a video that has 'lines' going up through the display? If you have it's because the correct shutter speed wasn't used when filming. Different monitors have different refresh rates at which they display their image, so it is very important to choose the right shutter speed

on your camera when filming these so that the rate of light at which the camera receives the image matches the rate of light at which the monitor is giving the image. I find that a shutter speed of 1/60 matches most monitors. This is also one of the few occasions when I don't double the frame rate at which I'm shooting. This is because a flickering monitor is *a lot* more noticeable than shooting on a shutter speed that is not twice what the frame rate is. As a matter of fact, I don't think the majority of people would be able to tell when a frame rate is 'incorrect'. If there's only one shot in your video that has a monitor in it then I would only shoot that shot with a different shutter speed. Once the monitor has been filmed, I would revert back to the original shutter speed so that the rest of the clips are matching.

A great example of the difference shutter speed makes to your shot is to film a water fountain or feature in your nearest park. If you film using a low shutter speed, when you play the image back the water will look nice and fluid and quite flowing. If you film using a high shutter speed the water will look like it's composed of billions of tiny drops rushing down.

When filming outdoors on a sunny day I usually crank up the shutter speed to make my shot darker but still take advantage of a low f-stop to give me a shallow depth of field. I do this when not shooting with an ND filter (see below).

The neutral density filter

A neutral density (ND) filter is the third aspect to look out for to get the correct exposure. It is essentially a bit of dark glass that goes over your lens – almost like sunglasses. Video-specific cameras have them built in, but for DSLRs you have to buy them

separately and screw them onto the end of your lens. ND filters give you the ability to make your shots darker when you're in sunny conditions without having to sacrifice any other levers that may affect the way you want your shot to look.

Adjusting the ISO

The fourth and last lever to pull is the ISO. I've purposely left it until last because it should always be the last adjustment you make when trying to expose your picture. Again, I'll keep this explanation very basic: cranking up your ISO brightens up your image. It does it in an artificial way – that is, digitally – not physically like opening up your lens (aperture) or removing an ND filter (black glass on top of your lens). Because of this, when you crank it up too much it starts creating 'noise' in your image. By noise I mean that kind of slightly pixelated look, as if the image has a layer of dust over it.

There are new cameras out there that minimise this noise really well even when shooting in dark places (the Sony AS7ii is one of the best DSLRs for shooting in low light), so you can confidently crank the ISO up when shooting in a dark nightclub and the image will still come out great!

The ISO you're going to shoot at really depends on your camera. For example, if I was shooting in a dark nightclub on my Panasonic GH5 I would not go over the 64,000 ISO mark as I know that it would produce a lot of noise in my shots. If they were still too dark I would brighten them up in post-production. However, if I was filming on a Sony AS7ii I would happily crank it up to 200,000+ as it's got better low-lighting capabilities. If you're shooting where there is an excess of light (outdoors on a sunny

day, for example), I would always have my ISO on the lowest possible setting so as to minimise digital grain.

ACTION!

Now that you are familiar with the technical aspects of shooting, let's get onto what you're shooting.

Should I use actors?

In pre-production you should have figured out whether your talent is going to be made up of actors or regular people being in front of the camera. Whatever you decide on, it's important to know the pros and the cons.

Using actors

The benefits of using actors are obvious. Actors will come across great on camera (good ones anyway!). They will also save you time. To give you an example, at Appliances Online we used to use an actual product expert on video who was a trainer on whitegoods. He used to get through about eight products in one day of filming, as he had quite a few takes and was generally starting and stopping whenever something didn't go to plan. A good actor can go through a long script all in one take, and if something doesn't quite go to plan they can ad lib and look comfortable and professional when doing so. When we replaced our product expert at Appliances Online with professional presenters, we went from filming eight products in one day to fifteen. We thought this would impact our engagement levels as there was reason to believe our viewers would connect more with a real employee as

opposed to a paid presenter, but stats proved that not to be the case. It's possible viewers didn't even realise the person was an actor.

Using regular people or doing it yourself

If hiring actors is outside your budget and you choose to front the video yourself then there's a few considerations to take into account. The first one is to practise a few times beforehand so that you look more natural when the actual filming day comes around. Practise in front of other people. When the time comes to film, you are likely to do it in front of a small crew so make sure you're prepared.

Don't put too much pressure on yourself. This is easier said than done, but the reality is that professionals themselves sometimes take up to 20 takes to get one sentence right. If this is happening to professionals then it should be happening to you to (although it does happen to the professionals a lot less often)! Don't get stressed when you stumble on that same sentence for the seventh time. It's not you being rubbish at presenting, it's just you being the same as any other human being on the planet. When I'm behind the camera I don't like saying to my subject, 'Take a deep breath and relax', because I feel it only draws attention to the fact that they are a bit nervous. It's okay (actually it's expected of you) to be nervous. Just channel those nerves into focusing on delivering the best possible piece to camera you possibly can.

If nerves do get the better of you, I find that some self-deprecating humour usually helps. It may sound a bit counterintuitive, but if you jokingly say that you're a bit rubbish at presenting it kind of points to the elephant in the room. Once you're aware that

everyone knows you're struggling and you've alluded to it, it dissipates some of the nerves and makes you preform better.

I always tell my customers to pretend that the camera is just another person they are talking with. It reduces the risk of them feeling overwhelmed by all the gear surrounding them. Another tip I usually give people who are going in front of the camera for the first time is to give themselves two seconds before *and* after speaking of just staring at the lens of the camera. A lot of people's natural reaction is to look away from the lens as they are finishing their sentence, and it really disengages their viewer. Keep the gaze on the lens!

The beauty of video becoming more disposable is that people are now accustomed to those 'erms' and 'uhhhs' used as fillers in between sentences. Don't be afraid to stop for a couple of seconds to gather your thoughts – it adds to the authenticity, especially if doing a Facebook live. A good editor will always try to cut them out to speed up a video, but it's not the end of the world if you include them.

In terms of body language, try to be as relaxed as possible. If your hands are in shot, hold them in front of you, creating a pyramid. This will stop you from fidgeting and make you look more at ease. Try not to sway when talking to camera – you'd be surprised at how many people do this!

Remember that the number one benefit of video is emotion and connection. So be yourself, be happy and relaxed, and just pretend that the camera is a person you are talking *with* not to. That should set you in good stead to make killer videos!

How to film an interview

One of the most popular shots we see in videos are interviews, and there's a very basic guideline to filming them: the rule of thirds. Stick to this and they will always look great. You can enable a grid to pop up in most cameras to show you the grid of thirds. If you cannot do this with your camera, simply imagine drawing two horizontal lines one-third of the way and two-thirds of the way across the screen. Then repeat vertically. This should give you a grid of nine squares (see below).

The key to framing a good interview is to place your subject so their body is in the middle of either the left or right vertical line and their eyes are intersecting the top horizontal line. If you have placed the interviewee on the right vertical line, make sure they look *across* the frame when answering questions. That means placing the interviewer on the left-hand side of the camera. Reverse the interviewer's position if you place the subject on the left vertical line.

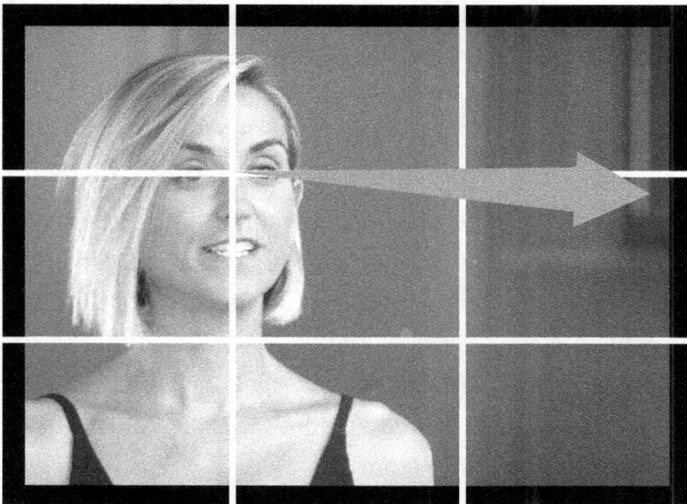

This rule of thirds is the most basic of interview filming techniques, and there are some very talented videographers who play around with it. Some completely break the rule and still make their shots look great, but I'll be the first to admit I'm not brave enough to do that, as if you get it wrong it will make your piece look awful!

The last bit of advice I will give on framing for an interview is to make the subject stand square on to the camera. That means toes pointing straight to the camera. The person will obviously have to look left or right (depending on how you've framed the shot) to look at the interviewer when answering questions, but I always encourage the interviewee to simply turn his or her torso slightly and to keep feet planted on the floor. This will give you a much nicer looking shot. It will also prevent those awkward shots where people keep shifting until eventually all you are left with is a profile shot, which looks wrong. If that's happening throughout an interview, don't be scared to stop people in between questions and ask them to re-shuffle!

Filming cutaways is also crucial. This is also sometimes referred to as 'B-roll' or 'overlay'. As the second name implies, this is the footage you are going to lay over the main footage. If for example you are talking about your website, you should film quite a few shots of someone using your website, clicking on different pages on your website, a close up of the person typing and moving the mouse, and so on. These shots will then come in very handy to bring your video to life in post-production. Not only that, they will also help mask any cuts that happen because of someone stuffing their lines up. You can stitch together two different scenes and use the cutaway to make that stitch look seamless. (See chapter 8 for more about using cutaways.)

GETTING GREAT SOUND

The last topic to cover in production basics is sound. And this is arguably the most important technical aspect of video production. If your video looks great but you make people struggle to hear you, they are going to switch off straight away. Sound is so important that production companies always have a sound recordist whose sole job is to record audio. If your budget doesn't allow for this extra person then it is paramount you still ensure the best possible audio for your production according to your budget.

Using the right microphone

Invest in a good microphone. In-built microphones in cameras, especially DSLRs, don't tend to be very good. The microphone you invest in doesn't have to be expensive – you can get decent ones for a hundred dollars or so.

The type of mic you invest in depends on what you're primarily going to use to film. If it's your smartphone you can purchase lapel microphones that work really well for them. If you are planning on using a DSLR then you can buy an onboard microphone for your DSLR that tends to work okay if the subject is always going to be close to the camera when talking. But unless you've got a very specific type of video to film in which the subject is always going to be close to the camera, this is very impractical. I would recommend a lapel mic that has a wireless connection to a receiver that sits on top of your DSLR. These are becoming more and more popular as they are used by famous on-the-go vloggers such as Gary Vaynerchuk and Kerwin Rae.

Recording outside

Things to take into consideration when recording sound outside include how disruptive even the smallest of wind gusts will be. Make sure you buy a wind shield for whichever microphone you end up using. These are usually called 'fluffys' as they are little fluffy things that absorb the impact of the wind on your microphone.

It's also important to try to minimise noise pollution at this stage. Things like car toots, alarms and general city ambient noise can get in the way of a clean recording. A lot of microphones and audio recording devices can record audio at different threshold volumes. I would recommend setting your threshold volume to very low when recording outside. That means that you eliminate the recording of noise pollution, and although your voice might sound a little bit faint, you can then crank it up in post-production without hearing all the other noise. It's better to err on this side rather than to record your voice and noise pollution and try to crank it down in post. This is because when you try to crank down the noise pollution you're also reducing the voice levels. Another little tactic that is good practice is to record ambient noise as a standalone clip. So just hit record for a minute or so and capture the noise pollution. This sometimes comes in handy if you struggle to stitch two different cuts together because they sound slightly different. Simply insert that bit of ambient noise in between the two scenes and it makes it a more seamless audio transition.

Always use headphones

Another must when recording audio is to use a pair of headphones *at all times* to hear what you are recording. I've had the misfortune of listening in with a pair of headphones before dropping them and just going off the visual audio guides. There's sometimes radio interference in microphones, and sometimes they pick up small pops that you cannot hear unless you have your headphones on. They are recorded onto the actual track and become a nightmare to get rid of when you come to the edit suite.

Sound effects

My first ever mentor in the industry told me to 'never under-estimate the power of good sound effects', a very good bit of advice that to this day still holds much truth. This obviously is to do with sound but is also a nice segue into post-production in the next chapter …

8. POST-PRODUCTION BASICS

Post-production is probably my favourite stage of the whole process. This is where you add the icing on the cake, and can make small amendments that make a world of difference to how you make people feel.

LABELLING AND STORING YOUR FILES

The key for successful post-producing is to be organised!

The first step in post-production is labelling and storing your assets in a way that will make them easy for you to find. Clearly labelling your footage is very important and makes editing quicker. I tend to label my footage with the name of the project and the date. This also means if I need to revert back to it in two years' time I'll be able to find it easily. Store it in folders on your computer that will make sense to you or your editor. If I use two

cameras, for example, I create a folder for each. I also create a separate folder where I store the audio if the audio was recorded separately from the cameras.

EDITING

Once you've got all your footage and sound correctly labelled and stored, it's time to open up your editing software.

Choosing your editing software

There are three big players in the world of NLE (non-linear editing) software. They are Avid, Final Cut, and Premiere Pro. Avid is mostly used in professional broadcast stations and Hollywood, though together with Final Cut they have been losing a lot of ground to Adobe's Premiere Pro over the last 10 years. Premiere Pro is now arguably the world's leading editing software for both professionals and amateurs. I personally moved from Final Cut to Premiere Pro about five years ago, and I haven't looked back.

If you don't want to buy professional software then your PC or Mac will have its own editing software you can use, either Windows Movie Maker or Apple's iMovie. These are user friendly and intuitive to use, and will produce good results. But be warned – if you use their in-built transitions too much, your videos will look horribly amateurish!

Getting started

Once you open up your software, remember the mantra of a good editor: be organised. Make sure you import all your footage and

assets into nicely labelled folders and keep everything tidy as you add more assets to your project.

If you're just starting out and don't know much about the technicalities of video, the best thing to do is to grab one of your shots and drag it to the 'new sequence' (or similar) button. This will ensure that the timeline where you're going to be doing all your work matches the footage you are using.

Your timeline is where you put your story together. If you're working off a storyboard it should be easy enough to follow, but when you're not, this is where you shape the story to tell it how you want. You can add pauses to build suspense, make quick cuts to increase pace, and generally shape how people are going to consume your video.

If you're completely new to video editing, it can be a good idea to drop in some of your footage and have a play around with the software first before starting on your actual project. This will allow you to develop a feel for how the software works, so that when you get onto your project you can get straight down to business.

Choosing your editing technique

There are two techniques people mainly use when editing: the 'additive technique' and the 'deletive technique'.

The additive technique is where you go through all your footage in the project panel in your software and only drag down the bits you might use into the timeline.

The technique I use is the deletive. I like to call it the 'ice sculpting technique'. The way it works is you dump *all* your footage

into a timeline. That is the ice block. Then you slowly go through all your footage, deleting the unwanted shots and only keeping the best ones in. That is the equivalent of the ice sculptor going through the massive ice block and chipping away at all the unwanted bits until she's left with the sculpture.

Both techniques work well, and you should use whichever one you feel most comfortable with – I just feel that the ice sculpting technique leaves less room for error and ensures you include only the best of your footage.

Keeping your audience engaged

As attention spans are very short nowadays, it is very important to add pace into your edits to keep your audience engaged. This is achieved by listening closely to what your subjects are saying and getting rid of any unnecessary fluff. These are mostly fillers in people's speech or long gaps in between sentences. This also includes repetition. You would be surprised at the number of times, in spoken language, people repeat a point they have just made. If you know you have shot plenty of cutaways for a short video you are putting together then I would recommend being ruthless with deleting these gaps, fillers and repetitions, safe in the knowledge that you will have enough cutaways to mask those cuts.

When telling your story, make sure you have a clear beginning, middle and end. It's very important to know the narrative you are planning to tell before you lay down your first clip. Having a clear structure will make your decision process in the editing suite a lot quicker. Creating a good narrative with a killer story that flows

really well is half the job done. Maybe just over half, as I believe a good story will always trump production values when it comes to engaging your audience.

ADDING THE BELLS AND WHISTLES

Once you are done with that, it's time to add the bells and whistles.

The polishing stage includes adding cutaways, sound design, music and colour grading, which is the technical way of saying you make everything look and sound awesome. This is the stage where, as a business owner, you must decide whether the extra amount of time, cost and effort in making your video look spectacular will yield a return on that investment. For a two-minute video you could spend as little as two hours on this stage or as much as two weeks.

Below I'll briefly touch on what the different levers of polishing are, and how they enhance your video.

Cutaways

'Cutaways' are when you add other shots into your video. The example we looked at earlier was if you're talking about your website, you can add cutaways of a person at a computer using your website. Cutaways will make your video more engaging. People tend to get bored of having a talking head deliver them content non-stop. If you add cutaways (also called 'B-roll') to videos it simply makes them more interesting as the viewer's brain gets more stimuli.

People tend to think that cutaways have to be literal and contextual, but the truth is that more abstract cutaways can work just as well. Off the top of my head a quick example I could give is talking about the release of a new product. The product doesn't exist yet, however. So, in the pre-production stage you could use the words 'when it comes to light', and as a cutaway have a sunrise. That would give the feeling of 'it's a product we are working on and it's yet to be released'.

The placement of cutaways in an edit is very important. Good placement makes a great editor stand out from the average ones. I've seen edits where a cutaway is placed just a frame too soon or too late and it ruins the video – also showing the editor's carelessness and lack of attention to detail. A lot of job descriptions talk about needing attention to detail, but I can't think of too many jobs where it's so evidently exposed if you lack this skill as that of an editor.

This is especially true when 'masking' cuts. 'Masking' a cut is the term you use when you insert overlay or B-roll footage in between two sequential scenes that you've recorded as separate shots, so it gives the impression that it was filmed and/or delivered in one take because you have 'masked' it by adding a cutaway where the two shots were stitched together.

When you're not masking cuts and are simply choosing to add a cutaway in the middle of a sentence, there isn't necessarily a right or wrong answer on where to place it. My personal preference is to start and end them with the natural start and end of a sentence – in my opinion this makes a video flow better. The obvious exception is when there is a direct reference to a cutaway, then I just insert it as soon as it is mentioned.

Getting the music right

In terms of the mood and feel of your video, nothing is going to dictate it more than the music you choose to accompany it. Choose the song wisely – and *make sure you have permission to use it!* It is illegal to use someone else's music without their permission or a licence to do so.

There's hundreds of great websites to find good music you can use, such as audiojungle.net and soundstripe.com. Even Universal Music has a website where you can buy licences for commercial music that isn't too mainstream. The licences from these websites will cost anything from $20 to $20,000 depending on the popularity of the song and its intended usage. A song bought to be used in a YouTube video will cost a lot less than a song to be used in international television adverts.

The beauty of these stock music websites is that you can search and filter for songs based on the mood of your video, so for example if you want an upbeat, energetic video, you type those words into the search bar and are presented with a list of potential songs to go with your video. Choosing a song is almost always one of the most time-consuming things to do in post-production. This is because you have to trawl through dozens of songs to make sure you find *exactly* the right one, with the right mood, the right rhythm, and the drops of beat exactly where you want them. As discussed in chapter 6, it's ideal to choose your music in pre-production if your video doesn't contain much dialogue. However, more often than not you'll find that you choose your music based on how the dialogue is delivered and how you've actually stitched the footage together. There is no right or wrong

stage at which to choose the music. As a rule of thumb, I would say that if your dialogue is driving the narrative of your video then choose the music in production. If the music is driving the narrative of your video then choose it in pre-production.

At the end of placing cutaways and music is when the most basic of editors will have a final video ready to be exported. What makes an editor stand out from the rest in terms of technical skills is their competence at sound design and colour grading. Bear in mind that for small business owners with limited budgets it would be okay to stop your video production at this point. But if you have a high-end brand and want your video to portray that, it's worth investing the time and money to keep polishing your video with sound design and colour grading.

Sound design

Sound design is one of those things that goes mostly unnoticed to a layperson. But, it enhances a video tremendously, and will make it a lot more interesting and engaging to that layperson – who may not consciously notice it!

Sound design encapsulates a lot of technical detail, such as 'mastering' all the different tracks on a video, and making sure they all play through the right 'channels' if your video is being played on a surround-sound system. For the sake of simplicity though, I'll keep my education on sound design to what business owners will probably need on a DIY video job, and that is mostly related to sound effects.

Adding sound effects

As stated before, don't ever underestimate the power of a sound effect (often called SFX). As I'm editing a piece, I'm thinking of where a sound effect is going to accompany a cut, a transition or a reveal. I still leave this until the very end to make my editing more efficient, but once I'm done I go through my whole video, scene by scene, adding sound effects. The majority of these are very subtle. It could be as simple as adding a slight thump when an ocean wave crashes, to more complicated stuff like adding reverb, filters and swooshes when there's a big reveal in an animation.

When going through your edit adding the effects, you have the power to direct your viewers' eyes wherever you want on the screen. For example, if you have a nice shot of a valley and there's suddenly a flock of birds flying by for two seconds only, you want your viewers to notice them! What you would do is gradually bring in the sound effect of birds flapping their wings, and have it at its loudest for the two seconds for which they are on the screen. That way you're subconsciously informing your viewers that the birds are coming (from off screen), and you'll have their full attention on them when they do appear!

Another simple sound design tactic is to add 'whooshes' and 'swishes' when things pop up or fly by on screen. This is mostly for when you're doing animation. If, at the end of your video, your company logo flies in from left of screen into the centre, add a simple 'swish' sound as it flies across the screen. You'll be surprised at how much it lifts your edit, giving it that classy, polished feel.

Getting it just right

Most editing software packages come with an audio meter gauge which goes red when your sound is too loud. It's called 'peaking'. When doing sound design, it's your chance to make sure all the levels in the video remain constant and they don't peak. You are essentially balancing out the dialogue, music and sound effects to make sure the right track takes precedence at the right time. Most importantly, make sure your music and sound effects are not so loud that you cannot hear the dialogue.

It takes a few playbacks of your video to get your sound engineering spot on. At this stage I play back my video without watching it, but purely listening to it and watching my audio meters to make sure everything is perfectly aligned.

Colour grading

Colour grading is probably the last step you would take in polishing a video to make it look like it belongs in Hollywood.

I cannot overstate how intricate a process this is, and how skilled and talented professional colourists are. The scientific knowledge behind colour theory that they posses is incredible, and a great colourist will twin this up with a flair for artistry that really makes videographers jealous. I can say that with confidence because I am one of those videographers! For the sake of business owners who want to dabble in elementary colour grading, I will share with you my experience in this field, as I have dabbled in it quite a bit over the last few years.

Simple colour controls

My experience is in playing around with simple colour controls. The look of my videos is usually quite saturated (that is, the colours are vivid) with a high contrast. I'll explain how I do this in Adobe Premiere Pro, as that is my editing software of choice. All good editing software will have similar functions.

Premiere Pro has an effect you can apply called Lumetri Color. You simply drag and drop this onto your clip and work your way down the effects it offers you, such as exposure, contrast, temperature, tint, saturation, and many more. The ones I mostly focus on – as you probably guessed – are contrast and saturation. I also like adding vignettes to my final pieces as I feel it gives shots a more cohesive look and makes the final piece look more fluid. I also achieve this through Lumetri Color.

If you don't want to play around individually with colour controls, one of the easiest ways to achieve a nice look is to download an 'LUT preset' from the internet. (LUT stands for 'look up table'.) A LUT preset is essentially a combination of colour controls that has been saved to give you a consistent, predetermined look every time you want it. You can either pay for them or find them for free on the internet. These are a quick, one-click way of getting the look you want, and they are also applied through Lumetri Color in Premiere Pro.

EXPORTING YOUR VIDEO

It is at this point that I'm usually ready to export my edit. There are hundreds of different export settings available to an editor,

depending on where and how the video is going to be played. With business owners in mind, I would recommend you export your videos in 'codec .h264' and as an '.MP4' file or a '.MOV' file. These are the most common types of videos that exist online, and they are compatible with both Macs and PCs. YouTube, Vimeo and Wistia will also take these formats.

* * *

Now that you know the nitty gritty of the production process, it's time to move onto what type of videos you want to produce for your business.

9. THE DIFFERENT TYPES OF VIDEOS YOU CAN CREATE FOR YOUR BUSINESS

As discussed in chapter 4, there are various different types of videos you can do for your business depending on what it is you are having trouble with. In this chapter I'll briefly talk about the things to consider when producing these different videos and what they are usually great at achieving.

PRODUCT REVIEWS

We've sold *a lot* through product review videos. Product reviews are aimed at prospects who are almost certain to buy, they just need to know *who* to buy from. The bulk of our experience comes from producing over 2000 product reviews and getting over 15 million views for Australia's largest appliance online retailer. And we've learned a lot from this.

Here are some of the nuggets of knowledge we've picked up along the way:

- Start with a good thumbnail. People are attracted to people, so if you are using a presenter to showcase your product then it's a good idea to have a thumbnail of the presenter smiling with the product. Our click-through rates increased when we did this.

- Keep it short. Our data showed us (and this is consistent with Wistia's general data on online video consumption) that the sweet spot for our reviews in terms of length was 2 to 2.5 minutes long. That kept our engagement levels at an average of 76%, which for a review of a toaster or dishwasher is not bad at all! People start switching off once you go past the three-minute mark.

- Don't talk just about the product itself! Talk about the *value* that the product brings to your customers. Always relate it back to them, and how it could be fixing a problem they constantly encounter. It's very easy to get lost in talking about how great your product is, but if you can't communicate its value in terms of how it's going to benefit someone then it won't get you too far.

- Cutaways and close ups of your product are key. People love seeing the details. Not only does it break up the video and make it more engaging, but we found a lot of people who watched our reviews would rewind to parts of the video where we were close in on a product, be it buttons, controls panels, handles or other features. Humans are good for connecting with your audience; close ups are good to showcase the actual product. It's a powerful combination when done right – I'd say keep the balance at roughly 50/50.

- People want to see the product in action. So plug it in, and get it doing what it does. That's what people are really after, so don't fall into the trap of just showcasing it without actually using it!

- Keep it honest. If you're honest, you'll build a lot of trust, and down the line that will enable you to sell more to your customers. If something isn't great, there's a million ways to phrase it to get that message across without necessarily being detrimental to your product. 'Entry level' for example was a term we used a lot to imply that it wasn't the greatest but it would do the job for someone with a low budget. People are not stupid; they realise there's a money/quality trade off with most products.

- Try to stay away from pushing the sale down someone's throat as customers are quite savvy now at spotting aggressive sales pitches.

SOCIAL MEDIA PROFILES

Social media profile videos have recently exploded onto the scene – the likes of Gary Vaynerchuck and Kerwin Rae being the pioneers of this trend. The great thing about these videos is that it's more of a quantity over quality approach. They are somewhat more disposable than other videos, so you can focus less on the production values and more on getting them out on a more con- sistent basis.

The key with these videos is having good content and telling your story well. Be emotive and provocative in your story and tell it with panache! As they are primarily going to live on social media

they rely on shareability, so connection is key here. Connect to your viewers by sharing emotions and stories they can relate to. If you do these videos well you will create a niche following and generate a lot of authority in your area of expertise.

Make sure you have a clear call to action in these types of videos. And stick to only one call to action too. I made the mistake early on in my social media videos of saying, 'Make sure you like, share and subscribe if you liked this video'. I gave viewers too many choices, which ended up being counterproductive as they didn't do any of these things. What works a lot better is to say something genuine at the end like, 'Before I go, it'd be really helpful if you could click on the like button for me'. On the note of connecting with your viewers, it is paramount that you interact with them in the comments section too. This will help your brand's reach, and show you really care about your viewers. Being reachable adds to the experience for the viewers.

One of the technical things to consider with this type of video in particular is the aspect ratio (this basically means the shape of the video). The proliferation of smartphone-shot social media videos means we're moving quickly towards square-shaped and vertical videos as opposed to the traditional rectangle videos (16:9 aspect ratio). Know your output before you start shooting your video. If you film with your smartphone set in portrait mode it gives you a vertical video (9:16 aspect ratio). If you rotate your phone 90 degrees and shoot in landscape then that would give you a traditional rectangle (16:9) video. At the time of writing, I would recommend shooting everything on your phone in land-scape mode to stick to the traditional aspect ratio. However, we are quickly seeing a shift towards more vertical video. The likes of

Snapchat and Instagram stories are really accelerating this trend. Knowing your output means you will know whether your video is going to take up the whole screen if someone holds their phone in portrait mode or whether it's going to have black bars on top (automatically placed by the software you are watching it on) and encourage people to switch the portrait orientation on their phone. Having said all that, I wouldn't worry about aspect ratio too much if you're a novice. I would concentrate and focus all my efforts on making your story the best possible story it can be. If your story is great, people are going to be engrossed regardless of what aspect ratio you filmed it in!

To add pace, it's very important to shoot plenty of cutaways to include in these videos. They will not only add authority but make you seem more relatable – increasing engagement. If you don't add any cutaways it will simply be a talking head video. Nothing wrong with them, they just serve a different purpose.

TALKING HEAD VIDEOS

Talking head videos, as the name implies, are when you simply have a shot of someone talking straight to camera – usually from the waist or chest up. As the scene is going to remain static, it runs the risk of being slightly boring, so here are a few tips to help you out:

- The story you're telling has to be brilliant. You've got to be very confident the content will resonate with your viewers, and tell it in an animated way. As the scene is static, we are relying on the subject to bring the video to life. Be loud, use your body language, and most importantly be emotive!

Try to be creative with the background you choose – plain white was made popular by Apple's iPod adverts in the early noughties, but nowadays it looks a bit naff if not done correctly; for example, if you use an off-white wall, or if you cast a shadow on the wall when trying to do the lighting.

- Shoot in a bigger frame size than what you are going to edit in. For example, shoot in ultra high definition (4k) if you're going to edit in high definition (1920×1080), or shoot in a 1920×1080 frame size if you're going to edit in a 1280×720 frame. Let me give you a visual example of what that means: imagine what you filmed is on an A4 sheet of paper. Your final edit is going to be exported into the size of a postcard. Shooting a talking head like this gives you the ability to shrink the A4 sheet of paper to fit the postcard. It *also* gives you the ability to 'move' the postcard to show any part of the A4 sheet of paper that you want. Essentially it gives you two camera shots!

- Be really ruthless with your cutting. This is a trick most YouTube vloggers employ. They cut all the dead air in between sentences. Even if it's a fraction of a second long, they chop it off. The end result is a video of a talking head with lots of jump cuts – a technique that looked unprofessional only 10 years ago but now is the norm of vloggers to add pace to their videos.

- I would try to keep these short. If you have a lot of content that you want to disseminate and it's definitely going to take you over two minutes then I'd be looking at breaking up that content into little tidbits so as to keep all your videos short and punchy.

INSTAGRAM VIDEOS

At the time of writing, my production company is experiencing a huge shift into producing social media–specific videos. The reason for this is that while Facebook supports 16:9 (rectangle) videos, 1:1 (square) videos look better. What has been the absolute game changer is the proliferation of Instagram as a video platform. And the best way to display videos on Instagram (especially in stories) is vertically, in 9:16 – essentially flipping that rectangular video by 90 degrees.

This means a whole new technique of filming if millennials are your target market, and let's face it, they have to be if your business is here for the long term! The main difference, if you are filming an Instagram-specific video with a DSLR or video camera, is to flip it 90 degrees when you are filming. That way, what you see on screen is displayed in exactly the same way as it's going to be displayed on Instagram.

When you come to editing, it may get a bit confusing. The trick is to remember to make your timeline a vertical timeline (usually 1080×1920). When you then import the footage you shot vertically it might not fit the frame. Rotate it by 270 degrees and – voilà – it should fit your screen!

The other consideration is the length of the video. It is very important that you don't go a single frame over 60 seconds if you're shooting a video to post on your timeline, and not a single frame over 15 seconds if you're shooting it to post as a story.

Marketers are getting very creative with Instagram video, and it's evolving so quickly that it's an exciting time for the video industry. I think it's the biggest revolution since the introduction of digital

editing software, and without a doubt the quickest revolution – it seems to be evolving quicker than anything else I've seen before in the industry.

PROMOTIONAL VIDEOS

Promotional videos are designed to make a splash! These videos really have to get the audience's attention from the word go. Film or buy stock footage that is different, beautiful, and will make people stop scrolling through their timelines in order to listen to your message.

These videos are hard to DIY. I would recommend outsourcing these to professionals as they require a bit of expertise to make them look great. And if they look poor they will actually be detrimental to your brand – customers will think that it's reflective of the quality of work you would produce for them.

Clarity is key for promotional videos too. Bear in mind you're more than likely targeting suspects, so aim for the lowest common denominator in terms of the language you use. Also be very clear in how you phrase *what* your product/service is and *how* it solves problems.

The music you use should be quite upbeat as well. As you're targeting suspects, you need something really fun and catchy to not only harness their attention but to keep it for a prolonged amount of time. Videos that are quirky and different usually perform best when getting someone's attention, but a well-produced, simple video could work better at keeping that attention for longer periods of time.

ANIMATION

Another type of video that is probably best left to the professionals is animation and motion graphic videos. This is because there's a whole new level of theory and artistry when it comes to 'key framing'. Key framing is essentially the process via which you animate graphics.

Animation is great for explaining software or other services that are quite hard to film. The lack of filming means they generally require fewer moving parts in the production process. You are not restricted by actors, weather, lighting and other factors, like you may be with real footage filming. Instead, all you need is a good motion graphics artist to follow your storyboard.

Animations are also great in that nothing really is impossible to show on screen. If you can imagine it then it can be drawn up and animated! It means you can produce a video on a product or service that doesn't even exist yet but is coming soon.

There are websites such as Animoto and VideoScribe that are designed to help amateurs create their own animations with ease. In my experience, having to learn their software is incredibly time consuming, so much so that it ends up being more expensive than just hiring a professional to do the job. Animoto's interface is slightly easier to use, but the videos produced seem very generic and uninspiring.

HOW-TO TUTORIALS

We've already discussed the marketing relevance of YouTube today, it being the world's second-largest search engine. But did

you know that the most commonly searched term is 'how to'? This means there's huge potential for any business owner to leverage their expertise through this platform, and of course video is their weapon to achieve this. Setting yourself up as an expert will lead to sales down the road.

The key to a great how-to tutorial video is clarity. You have to be pernickety in covering every single detail of what you're explaining and always keep the language simple. And don't assume that people will have any sort of existing knowledge about your topic.

How-to videos are very popular with suspects as you're immediately seen as an expert, and they also benefit your customers in providing a better experience with your product or brand. Bunnings jumps to mind as a company that is great at using how-to videos to enrich their customers' journey with them and build their brand loyalty. They do this by offering multiple how-to videos for recently purchased items. If you've just bought all the materials for a deck or garden shed and come unstuck when constructing it, Bunnings don't leave you stranded after the purchase – they continue the multiple touchpoints with their customers by offering post-purchase help, with videos and also educational sessions in store. These videos aren't polished at all, but as stated before, they don't have to be – it's all about clarity and delivering the message well.

Close ups for this type of video are also very important, especially if the product you are showcasing is small or has many buttons or other small details. Make sure there is no ambiguity left for the viewers when showcasing or explaining any part of your product.

If you are producing a how-to video guide of your software it is also very important not to cut abruptly from one screen shot to the next without explaining to the viewer how they would go from one screen to the next in the software. A viewer will only rewind a video so many times if they think they have missed something before switching off completely – make sure your video doesn't suffer this fate!

As mentioned in the previous chapter, a sound effect can go a long way in one of these videos. If your software, for example, does something on the bottom left-hand side of the screen when you click on the top right, and you want to emphasise this, then use a beep or a whoosh to do this. You could obviously use a voice over too, but sound effects tend to be cheaper and you would save on the cost of a voiceover artist. It can also help in making your video punchier.

CORPORATE VIDEOS

Corporate videos are one of the most common videos produced for companies. Corporate videos are when big corporations (think a place full of corporate-looking workers with floors full of cubicles) create a video about their company and what they do. They work well because they humanise big brands that previously had a faceless connection to their customers. They are usually very generic in that they explain what the company does (usually by a CEO or other executive), cut to an overlay of people in the office, and finish with the corporate logo.

There are a few pointers to follow if you want your corporate video to stand out above the rest:

- Don't be afraid to get that killer quote. Perhaps more so than in other videos, you've got to be doing your editing in the filming stage with corporate videos. And this is especially true when getting sound bites. If you ask someone what the culture is like in the workplace and they simply answer, 'Yeah, it's good', it's not going to work well in your final piece. If that happens, explain to them that you need self-contained quotes and that they need to include the question in the answer. So, get them to say something like: 'The culture in our office is very good because of a number of initiatives. We get a lot of flexibility, our family comes first, and to top it all off we get free lunch on Fridays!'

 An answer like that will give you so much more scope to play with when it comes to post-production. I cannot emphasise enough how important it is to get great quotes in corporate videos, as it's going to be the narrative that drives the piece. It can get awkward asking an interviewee to repeat themselves four or five times, and sometimes you even have to paraphrase what they said and ask them to say it your way, but believe me, it will be worth it in the end!

- Another tip is to film the interviews with two cameras. Have one set up in your standard interviewing frame following the rule of thirds (see chapter 7), and then get creative with the other camera. You could have it as an extreme close up (I personally like this look, but be warned that a lot people don't like close ups of themselves and sometimes come back saying they don't want that angle used), or have it quite wide to show the position of the actual set up. Anything in

between usually works as well, as long as you are giving your viewers something interesting to look at.

The beauty of having a dual camera set up is that it will allow you to cut between shots with ease. This helps in two ways. One, it makes it easier for you to cut wherever you want, even if you don't have a matching cutaway shot, safe in the knowledge that you could just cut to the other camera. Two, it adds pace for people watching your video, ultimately making it more engaging!

- The last tip to film extraordinary corporate videos is to film with a high frame rate. Anything above 50 frames per second will work well (see chapter 7 for information on frame rates). This will give you the ability to slow things in post-production, and as everybody knows, everything looks better in slow motion. Once you have done all your B-roll filming, you'll be surprised at how much better the video looks when you have someone typing at the keyboard in slo mo rather than actual speed. Someone walking into a building looks so much more epic when shown in slow motion rather than real time, and that will permeate through to your brand.

LIVESTREAMS

Livestreams are phenomenal for connection. If you feel like you're lacking a connection with your customers then stop reading this straight away and do a livestream on Facebook, Instagram or Twitter. Not only do the algorithms of these social networks favour livestreams over any other content, but you'll be targeting the innate human emotion of curiosity when you film these. People will want to see you warts and all, and get to know the

real person behind the brand. My first tip for doing livestreams is simply to do one!

The beauty of livestreams is that mistakes are *expected*! So if you stumble or forget words mid stream, it actually looks standard! You can do a livestream pretty much about nothing and you'll still connect with your customers. Having said that, tip two is to have a good story or message that you want to talk about – this will resonate more with your customers.

Tip three is to ensure your internet connection is solid. There's nothing worse (and it's happened to me a few times!) than having to restart your stream because the internet drops out. Not only do you force people to re-engage with you, you lose out on true and detailed analytics of how your broadcast performed.

It is also very important to engage with your followers live if you can see what they are writing in the comments section of your livestream. As livestreams are all about instant connectivity and gratification, make sure you acknowledge people on video as they say hi to you. This will make your viewers feel valued.

Lastly, be yourself! In livestreams there's a lot of room for forgiveness when things don't go well. There's no point in using a script as things will more than likely take a different course than you anticipate. It's how you spontaneously deal with these things that will show your customers who you really are. Don't go into livestreams thinking that you've got your brand's reputation to uphold, go into it thinking that this is an insight into real humans doing their everyday thing. Enjoy it, don't put too much pressure on yourself, and have fun with it!

TESTIMONIALS

Testimonials are probably the best way to promote your business. This is because viewers will subconsciously realise that the people on screen singing your praises had exactly the same problems *they* are currently having. Viewers will relate to them straight away, and if they are saying how great you were at solving their problem, then surely you'll be able to solve the viewer's problem too!

It is very important never to stage these. Get actual customers – people nowadays are too savvy and will see straight through an actor. Getting an actor is one of those things that will actually be detrimental to your brand.

In getting real customers, make sure you select customers who have really been delighted with your service. Every company has them, and the beauty of targeting these people is that they somehow feel indebted to you for your great service, so they will more than likely say yes to appearing in front of a camera for you.

Before you start asking them about how happy they were with your service or product, it is very important that they set the scene by telling the viewers what problems they were having. This is key as it is what – in their own words – is going to connect and resonate with your future customers. After they have spoken about how you fixed the problem it's also very important that they talk about the *prize*. By prize I mean to get them to talk about what your product/service has got them.

To use video as an example, I wouldn't get a customer to talk about the epic videos we produced for them, I would get them to talk about the benefits for their company, stuff like, 'We now have

1000 weekly regular viewers watching our blog and connecting with our brand'. Or, and this is a true testimonial from our dear friend and customer Gabriela Rosa, how video has helped her business break down geographical barriers and scale her business as an international brand.

Ask very open-ended questions and let the customer elaborate. Unlike corporate videos where I would perhaps tell people how to phrase answers, I wouldn't do that here. This is because hearing problems (and solutions) straight from the horse's mouth will create a stronger connection with viewers. It will also help you understand your clients better and consequently make your products and services better. Ask them to give you self-contained answers, but that's about as far as your input should go.

EVENT VIDEOS

If you're in the events industry, there's no better way to showcase your product than a well-produced video. It is the perfect opportunity to capture all the emotions that go with video and to enthuse future clients into buying tickets for your next show!

Apart from product reviews, the majority of our experience comes from producing events videos. At the time of writing we are video partners with The Color Run in Australia, and we've produced many promotional videos for West End Musicals in London and music festivals in Australia. The secret is to capture the *emotion*, not just the event – something a lot of videographers fail at!

Planning, like with all videos, is key here. Think about what you're trying to communicate with your event video and how

you're going to achieve it. In the case of The Color Run, they pride themselves on being the happiest five-kilometre run on the planet, so the obvious shots to capture are many smiles.

Another key point in events production is the composition of your shot. You never want your event to look empty, so frame shots in a way that it always looks crowded. This can be achieved by using lenses with higher focal distances and having close ups, but it would become a bit boring. You need a bit of variety, so when shooting wide shots it's imperative that you fill the frame with lots of people. Talk to the people you are filming and ask them to bunch up if the event is indeed a bit low on numbers.

This brings me to the second point, which is about directing the crowd. Although there's an art to catching spontaneity on film, a lot of the time you see it with your eyes but miss it with your camera. But don't think the moment is gone; go up to the people and ask them to do it again for the camera. You will be surprised at how willing people are to help you out. It's all about capturing emotion – that is going to be the driving force of your video. If you miss it first time around, make sure you ask people to recreate that smile, or that skip, or that blow of a kiss they just gave their friend. Sure, it may not be as genuine second time around, but you'll be surprised at how good it looks on camera!

Knowing the song you are using in the video before filming the event is going to make your video exponentially better, because you can prepare shots around the lyrics and beat of the music. If I know the song I'm using starts mellow and then has a pick up in beat a third of the way through the song, I know that my ratio of filming slow epic shots compared to crazy energetic ones is

roughly 1:2. Likewise, if the song contains the word 'heaven', for example, I might consider shooting a time-lapse of the clouds or something of the like.

Never shoot an event from the sidelines. Always get in among the punters so you can really feel what they are feeling. That's going to make it so much easier to convey that emotion through your video. I do this even when there are water hazards that pose a threat to my filming equipment; it's that important to have the video connect with its audience! (Still ... be careful with your gear.)

Lastly, remember that you are telling a story. It's not good enough to film a sequence of good shots and stitch them together. Think about what you're trying to say through these images and structure them in a way that you think will elicit certain emotions from people. Try to take viewers on an emotional roller coaster. This is usually dictated by the song you choose, so make sure you choose wisely and have your images supplement that journey.

If your event is of a corporate nature, there's an art to making it look stupendous when all it entailed was people sitting down for eight hours listening to speakers. This is quite hard to achieve, but similar rules apply. The framing must be spot-on to showcase the event as being busy. And you have to be very aware of what is being said on stage and when a presentation is about to finish. This is because the majority of the action you will be getting is people clapping. Woo hoo – rock 'n' roll!

I know it doesn't sound like much, but not a lot of 'action' happens in corporate gigs. Your videos will be driven (and made awesome) by the quality of the quotes you get at the end of the

event. Make sure you ask people why they enjoyed the day, who their favourite speaker was and why, and what their biggest learnings were. I cannot emphasise enough the direct link between the quality of your quotes and the quality of your video. Apart from quotes and getting people clapping, the only other opportunity you have at these events to get good shots is when attendees have a lunch break and a tea break and you can film them mingling. If you don't get these then your video will be a collage of different people on stage, clapping, and comments afterwards – it will be boring!

Always remember to record the audio straight from the audio desk at the event. Most places will happily let you plug into it. If you're recording from the audio desk you don't really have to worry about the sound quality – these desks are usually handled by someone checking the audio levels and making sure they are correct.

SIZZLE REELS

A 'sizzle reel' is like a showreel. It's a compilation video of all the best takes or best moments from other videos put into one video. Sizzle reels are a great way of showcasing the best of what you, your company, or your product or service has to offer. They require quite a bit of footage, so don't be tempted to do one if it's your first foray into video.

The beauty of sizzle reels is that half the editing is already done for you in that you know all the shots you pick will be great shots (they were used in the original edit for a reason!). This is also the

biggest potential trap. It's only too easy to put a montage of great shots together and it be just that: a montage. You've got to remember that you're still trying to tell a story, so break up sequential shots from a previous edit as much as you can to ensure you're telling a new story.

Sizzle reels are all about generating excitement and buzz. It will mostly be driven by the music you choose, so invest some time in picking the right song. The message will be mostly the same throughout the video (how great something is), but don't be tempted to elongate the video unnecessarily simply because you've got enough fantastic material to do it. Keep it at approximately 90 seconds. Any longer and you run the risk of boring your audience. As a matter of fact, the shorter the video the better. If it's 'too short' it will leave people wanting more – which is *exactly* the feeling you want to be eliciting! We recently did a sizzle reel for Cuba Gooding Junior's announcement as lead role in *Chicago* the musical and made it 30 seconds. We obviously had more than enough fantastic footage of him, but it was for social media and we wanted people feeling excited – and waiting for more. So much so that they would go and buy tickets to the show.

When working with different footage from various sources to create one video, and this happens mostly when working on sizzle reels, make sure you convert all your different forms of footage into the same type. You may have different-sized footage encoded to different specs. It is very important that before you start any of the editing you have converted them all into a uniform size and/or spec.

Another tip, and this is for when you've really gained some confidence in the software you're using, is to try to use the raw footage of the original video. This obviously only applies if you have it. Don't use the exported final version of the video if you have a choice, as that will have all the colour correction, music and sound effects burned into it. You give yourself a lot more scope for manoeuvrability and improvement if you use the raw files. This doesn't mean having to re-cut all the different videos again. If you're using Premiere Pro, for example, you can open a project file within a project file. This opens up a final edit in your timeline, at which point you can copy across the scene you want with or without colour correction, music, sound effects and any other edits.

EMAIL SIGNATURE VIDEOS

One of my most successful videos is my email signature video. I've added a play button to my email signature that, when clicked, plays a tongue-in-cheek video saying 'They actually clicked?! How nosey!' It then goes on to introduce me and explain all the services my production company offers.

The first thing people mention when I'm networking or after I've arranged a meeting is how much they enjoyed the video, and how they feel like they know me a little bit already because of it. It elicits a bit of trust, and that is why I would recommend everyone having a video email signature. It provides an ice-breaker when meeting people face to face, and it shows you're willing to connect with your customers that little bit more than the competition.

WHAT EACH TYPE OF VIDEO IS GOOD FOR

To summarise each video type's purpose and what problem it could solve in your business, I've put together a table for you.

Video	Target	What it brings to your brand
Product review	Prospects	Conversion. Turns warm leads into customers.
Social media profile	Suspects, prospects	Awareness. Exposure.
Talking head videos	Suspects, customers	Engagement. Education.
Instagram videos	Suspects, prospects, customers	Targeting millennials. Exposure. Engagement.
Promotional videos	Suspects	Awareness. Exposure. Establishment of brand.
Animation	Suspects, prospects, customers	Creating videos from hard-to-film concepts and ideas. Bringing software to life.
How-to tutorials	Suspects, leads	Awareness. High visibility through YouTube.
Corporate videos	Customers, prospects	Builds trust in brand. Authority.
Livestreams	Leads, customers, prospects	Connection. Exposure.
Testimonials	Leads, prospects	Relatability. Connection. Engagement.
Event videos	Customers, prospects	Emotion.
Sizzle reels	Prospects	Authority. Exposure.
Email signature video	Prospects, leads	Trust. Innovative. Human-to-human connection.

10. HOW USING VIDEO GIVES YOU MORE TIME TO WORK ON YOUR BUSINESS

Time *is* money. Any business owner will tell you this. And they will tell you that they need more hours in the day to invest in their business. Well, guess what?! I've got great news: video gives you just that! Below are a few video tactics our customers have employed to give them back time to work on their business.

ONBOARDING

Gabriela Rosa was my first ever customer when I started my company. She is a fertility specialist who reaches thousands of people around the world and treats patients on every continent. The majority of her patients are in the US, Canada, UK, Australia, Hong Kong and Singapore. She's since become a good friend *and* business mentor, and she is *the* perfect example of how to

utilise video as part of your onboarding strategy. She uses video as part of welcoming her patients into her program. Doing this has given her the time to attend to three times as many patients as she did before starting her video strategy, and in doing so helps them deliver healthy babies into the world. I know what you're thinking, and you *are* right – I'm pretty much saying that Gabriela's videos not only give time, but they give the gift of life!

Gabriela's strategy can be used by many different professionals though – and in doing so it automates a lot of the things you do in person. Things that you think can only work by giving your personal touch. And you're probably right in thinking that, however that's the beauty of video – your customers still get that personal touch but you only do it once! Some of our other customers who have used video to onboard their clients include negotiation experts, marketing experts, CEOs, healthcare professionals, and many more.

The reason these business people have opted to use video onboarding is that video really helps them in breaking down geographical and international barriers within their business. Both Gabriela and my negotiation expert customer now get the majority of their business from the US, even though they're both located in the Eastern Suburbs of Sydney, Australia. And because of video, both their Sydney customers and their overseas customers get *exactly* the same welcome and induction into their programs. That's the benefit to their customers. The benefit to them? They only spent one day filming a variety of content for their customers. *One day*. And they use that video content daily for the rest of the year!

TRAINING

We've worked with plenty of Human Resources teams that pro-
duce videos to train their staff. This is great as it gives everyone an
informed introduction to their new company, the way it runs, and
the values it operates by. Not only is the message uniform because
everybody watches the same videos, but it's delivered in a concise
and entertaining way, which enthuses the new starters even more.

Instead of HR executives having to induct new staff at the begin-
ning of each month for up to a day, they ask us to produce a video
that they can play on a staff member's first day that does exactly
the same trick.

The value of these videos to HR departments (and the Accounts
department more specifically!) is that they end up saving at least
a week's worth of salaries annually by having this process done
by video. Instead of having that HR executive spend a day at the
beginning of each month taking new starters around the various
locations within the business, it can all be done virtually through
video, without the new starter leaving HQ.

It gives HR teams so much time that they can go back to planning
the really important team bonding exercises. And I mean it – they
are *really* important.

CONTENT[5]

Imagine you film a video that showcases how much of a leader
you are in your industry. It's great, people love it, and you've got
yourself one awesome piece of content. At least that's what you

think. The beauty of video is that by doing a video you're actually producing *four or five* different types of media at the same time!

Podcasts

Once you have finished your video, you can export the mp3 file of that video and get a podcast. So if you're ever concerned you have so much information that you cannot pack it all into a short video, take a punt at producing a longer one that can always be exported as an audio file. People would be more likely to listen to a 10-minute podcast as they are driving than watch a 10-minute video in the office.

Articles

Once you have finished your video, get it transcribed. There's an awesome little app called Rev. You can find it for your desktop too at rev.com. They are the Uber of transcriptions, and I absolutely love them! You can send them any video (via YouTube or Vimeo) and they will transcribe everything for only $1 a minute! And they usually send it back within a couple of hours! Imagine that – your beautifully polished two-minute video transcribed into an article – and without you having to type a word!

Blogs

This article can then be turned into a blog entry. It's pretty common knowledge that blogs really help your SEO reach, and a blog accompanied by a video will have those SEO robots on steroids!

Webinars

Then lastly, and again applicable if you've done a longer video, you can turn it into a webinar. Simply add a few slides about what you're teaching or the information you're disseminating and bam! You've turned yourself into a teacher with great supporting material!

CUSTOMER SERVICE AND FAQS

We've worked with customer service teams before and asked them what people most often ring up and ask about. You'd be surprised at how much time they waste giving the same answers again and again over the phone.

The solution? Record video answers and watch your call queue dwindle! Give the videos exposure on your website and you'll save your support staff hours in time and reduce your overheads.

The same logic applies to your company's frequently asked questions section on your website. Have the information delivered in video format to save you and your customers time.

INTERNAL COMMUNICATIONS

Communication is a big issue in big companies. A lot of staff don't hear enough from the top and so staff feel disengaged.

Instead of having heads of departments or CEOs going around the company giving the same talks and/or speeches, we've had clients record video messages to disseminate across the company. This saves executives hours wasted in travel and repeating speeches

– and bearing in mind they are usually on the big bucks, it means an immediate return on investment when producing video content.

E-LEARNING

One of the quickest growing forms of learning is electronic learning, and in part this is being driven by video. And it's not only educational institutions that are jumping on board this method of teaching. We are seeing more and more business owners utilise this great method of exposure, not only to educate their customers but to establish themselves as an authority in their field.

The way this is saving them time is that by recording a series of modules and chapters they eliminate the time it takes to give this information in person. Most of our customers still conduct workshops as well, but video reduces the number of workshops they have to do while generating another revenue stream.

* * *

There are many ways to get creative and re-purpose your video. Just *one* video can be recycled into many different formats – giving you an incredible amount of valuable content and saving you loads of time along the way.

There's nothing better than a good metaphor, and as you can see, video enables time travel. Whether it's having a perpetual salesperson for your ecommerce business or sharing with your customers some of your intellectual property, video leverages the time in your business better than any other tool out there. So go out there and break the space/time continuum; make some killer videos for your company!

11. GETTING YOUR VIDEOS SEEN

As you've seen throughout the book, producing videos can be a lot of fun! Having said that, it requires hard work too, and all those efforts would be in vain if you don't give your video the best opportunity to be seen. It needs to get the exposure it deserves. A lot of videos that are produced are then left to rot at the bottom of a website or are lost among the millions of videos uploaded to YouTube each month. Don't let your video suffer that fate!

CHOOSING YOUR PLATFORMS

The first thing you've got to think about is what hosting platforms you're going to choose. The most popular ones are YouTube and Vimeo. They are both free (although Vimeo does have paid options as well), and will allow you to embed your video almost anywhere. Wistia leads the way in hosting video for businesses.

This is because their analytics tools are very powerful for marketeers, and the platform integrates seamlessly with marketing software such as HubSpot and Infusionsoft.

The beauty of YouTube is that it's the world's second-largest search engine, so your video is in a good spot to be seen. Having said that, it needs to stand out from the rest of the noise and the six million videos uploaded monthly!

Vimeo's player is a little more elegant than YouTube's if you're going to embed videos on your website. Having said that, Vimeo is traditionally more for creatives and not for businesses. I would always recommend business owners use Wistia to host their content. This is because through its powerful analytics tools you can see *exactly* how your customers are engaging with your content. And this makes any future video you produce better!

PLACING YOUR VIDEOS

Once you've chosen your hosting platform, there's a few other tips to getting your video seen. The first is placement within your website. If you've gone through the time, effort and cost of producing a video, invest a bit more time and talk to your web developers to have it visible within your site. The easier it is to find, the higher the play rate it's going to have, and the better results you're going to get from it.

If it's an About Us video you have made for your company then I recommend having it on your splash page or high up on your website. The video being 'above the fold' on your site makes an

incredible difference to the play rate it gets. ('Above the fold' means the video is visible on your home page without people having to scroll down the page. So, basically it's at or near the top of the page.) At Appliances Online we've seen that bigger videos below the fold get played fewer times than small thumbnails above the fold. So, just like in real estate, remember it's all about location, location, location!

CREATING EYE-CATCHING THUMBNAILS

A great thumbnail is paramount if you want people clicking on your video. The biggest mistake you can probably make when uploading your beautiful final video is to let YouTube or Vimeo randomly select a thumbnail for you. Make sure you select one that will get people's attention. Smiley, happy faces are scientifically proven to increase play rates – this is because humans are attracted to humans, and there's nothing better than a genuine smile to tap into viewers' happy spot to entice them to click!

A great way to get inspiration for a thumbnail is to trawl through videos of famous vloggers on YouTube. Most of them have really nailed the art of a good thumbnail. They usually include the titles of their video, next to an attractive image of someone in the video. This is all against a background of bright, bold colours. Even the click-bait videos (where there's an attractive woman in a bikini being eaten by a half-shark–half-unicorn beast!) are a great source of inspiration. Copy their style – but by all means keep it relevant to what your video is all about. There's nothing worse than a deceiving click-bait thumbnail!

PRODUCING QUALITY

It sounds obvious, but you have to start putting quality content out there. As we've discussed throughout the book, it doesn't necessarily have to be in terms of production values, but *definitely* in terms of content.

Make sure you have a good story, a story that will resonate with your audience and give them value. Value is the key word here! Once you've got that story, make sure you tell it well and that you connect with people – connection is about anecdotes; about things that people can relate to you through. Most of your exposure will come organically (that is, being shared and viewed without you paying for it) if your content is good.

INVESTING IN SOCIAL MEDIA

Unfortunately, due to Facebook's algorithms it's now quite hard for a video to reach audiences without a little bit of money behind it. I'm not saying it's impossible, just harder, no matter the quality of the content. So put a little bit of money behind it on Facebook, and if the quality is good enough, watch the organic views explode!

Targeting your audience correctly requires a bit of expertise too. I would recommend having a chat with a social media expert to make sure you are targeting the right segments – this will help your video get more views, so do consider your chat with the social media expert as something that will show returns on the investment.

USING FORUMS

Forums are a little hidden treasure when it comes to driving traffic to a video. A lot of people are oblivious to their existence, but the truth is that they drive incredible amounts of online traffic. Link to your video on forums. Make sure you contribute to the forum though, don't just copy and paste the link to your video as it will look like spam. You'll be surprised at how much traffic a website like reddit can generate for your video.

Specialised forums are also great to give your video legs. For example, if your video is about a new vegan recipe then get involved in the current online discussion on this topic and find a way to integrate your video into your comments. It will give your video the initial traction it needs to get it flying!

12. MEASURING YOUR ROI

It's very important to always have a goal when making a video for your company. Occasionally you might do just-for-fun videos. We've produced these when we want to show off a company's culture, or maybe as a thank you to a customer. These are very rare though, and I would never recommend making a video just for the sake of getting on the video bandwagon. Make it to solve a problem. And make sure you measure how successful the video was at solving that problem.

If you want to be able to accurately measure the performances of your videos, make sure you use Wistia as your video hosting platform. As explained in the previous chapter, Wistia is like YouTube or Vimeo in that it hosts videos – but when it comes to analysing the performance of your videos, it blows YouTube, Facebook and Vimeo out of the park. Its analytics capabilities are the best in the world.

Most videos are made without a strategy or measure for success, so below are a few pointers on how to measure the return on investment you're getting from video.

SAVING TIME

Video saves people tonnes of time. This is probably the biggest value we bring to our customers and one of the easiest metrics to measure.

Do you have onboarding strategies in place in your business? Be it training, HR, inductions, and so on. Produce a video that saves you from having to give all those boring Powerpoint presentations. If a video stops an employee on $500 a day giving one presentation a month, then in a year you can measure the ROI on that video as $6000.

As discussed in chapter 10, Gabriela Rosa was enabled by video to onboard three times as many patients. I'm not privy to her numbers, but increasing capacity by three times would presumably mean three times the revenue. If not, at the very least it would free up her time by one-third, which at an imaginary salary of $1,000,000 a year would mean approximately $300,000 ROI on her video strategy.

INCREASING EXPOSURE

A lot of our customers worry that no-one is going to their website, and they have to chase their leads instead of potential customers coming to them. Video is the easiest, most digestible way to be seen and heard.

How do you measure if you've been successful at elevating your exposure?

This one is simple: views. Set yourself a target of how many views you want to achieve for your video. How many views are you going to pay for through Facebook and YouTube advertising? And how many do you want to achieve organically? This cannot be a figure plucked out of nowhere – think of your marketing costs in terms of 'pay per clicks' through Google and Facebook and work out a realistic number of impressions you want your video to get based on a solid, targeted campaign.

After the video has been produced, go out there and hit that target! It can be done by putting some money behind it, but if the video is engaging enough this can be achieved (and even sur-passed!) organically. You should then see the superior conversion rates compared to other traditional media.

BUILDING ENGAGEMENT

Connection is one of the biggest desires for companies. A good connection with your customers is paramount to keep business thriving. The way we measure connection is with engagement lev-els. The equation Wistia uses to measure engagement is:

Engagement = Hours watched ÷ (Total plays × Video length)

Luckily for you, if you choose Wistia as your hosting platform, it does all that in the background for you and tells you an average engagement per person who sees your video. No need for you to crunch the numbers!

Assessing your connection with viewers

You can use the following figures to assess your video's connection with its viewers:

- Under 50% average engagement is not great – this shows you're not really connecting. It means that on average people are watching less than half of your video, so the back end of your content is not being seen. What if that's where you had important information? If you're getting these numbers, I would recommend re-editing your video to try to increase engagement with your customers.

- Between 50% and 60% is okay. You've got to bear in mind that many people don't watch a video from start to finish. A lot of people click away, only to come back and finish watching at a later date, so these figures wouldn't necessarily mean they are only watching over half of the video. I would look at 'heat maps' of how your video is being consumed, and if there's a lot of people clicking away in the first seconds then your video is perhaps not resonating with a wider audience but resonating well with your targeted audience.

- Between 60% and 70% is good. People are busy and our attention is strained. Global trends, when taking all online video into account, show that two-thirds engagement is actually a good return. This is especially true if your video has had quite a number of hits (say, more than 1000). If you're getting that figure from only a dozen views it's probably not as impressive.

- Between 70% and 85% is great. Respected American video agency Vidyard released a study which found that only 5% of

videos worldwide retain an average of 77% of viewers to the last second. That goes to show that it's virtually impossible to keep viewers glued to your video for 100% of its duration. So if your engagement levels are around the 70% and 85% mark you really are performing well above the average video content producer! Keep up the good work, and try to replicate the good format and storytelling techniques you are using.

- Anything above the 85% mark is phenomenal really! People can click away from your video when a simple phone call interrupts them, or when they hear the boss coming. That's why 100% engagement is virtually impossible, especially when the video gets a lot of views. If you've had a few thousand hits and are over the 85% mark then you really have nailed it! The content, style, messaging and production values (heck, the whole thing!) are really working well for you and your brand. Your video is officially one of the most engaging videos on the internet!

GENERATING LEADS

If you are using videos to turn suspects into prospective clients, measuring leads is the best way to see if you are being successful. The best way to do this is to prompt people with a call to action that they can act on as soon as the video has finished. You can do this via annotations on YouTube, but I would really recommend using Wistia again. Wistia allows you to place bespoke buttons anywhere on your video with customised CTAs. For example, you can give away a few tips and tricks in a video, and after the first two tips pause the video and only allow people to keep watching if

they give you their email address. If your content is good enough (which it should be after reading this book!) then there's a great chance that suspects will turn into prospects at this point by providing their email address.

Other successful CTAs we've put directly in videos include 'Sign up here', 'Shop here' and 'Learn more'. These CTAs will be indicative of whether people are connecting, engaging and being enthused by your video. Wistia allows you to measure the percentage of people prompted by your CTA who actually click on the button.

Once you have gathered these results, it's important to measure them against other lead generation platforms you have to determine the return you are getting on your investment. How many sign ups to your new course are you generating from direct emails (EDMs) compared to a landing page with your video? How many more visits to your website does a video bring over an image on Instagram? Do you have an in-house EDM manager and/or photographer? If you're having better results from video then perhaps it's best to invest their salary into an in-house videographer instead.

CONVERSIONS

Probably the biggest measuring tool is conversion, as it measures a dollar figure coming into your business as a direct result of the video which you can then measure against money spent on the video.

If you link your Google Analytics account to your Wistia account, you can create segments to compare conversion rates and bounce rates between people who watch videos against those who don't. This analysis helped our company determine that our videos were quadrupling conversion rates for one of Australia's largest e-commerce sites – that was one hell of a finding!

Knowing their average order value and the exact dollar value a video cost to produce also allowed us to discover the incredible margins they were getting on their videos. Some were up in the thousands of per cent!

A/B testing is one of the best ways to test for conversion too. Simply run two versions of the same page – one with a video and one without. Make sure you have the same message and call to action in the page, and see which one converts better. I'll put my house on the one with video converting better for you! We have never seen a detrimental impact to putting video content on our customers' sites.

13. THE INTANGIBLE BENEFITS OF VIDEO

We've mentioned all the ways in which you can generate a return on your video investment, and a well-produced story will bring a lot of benefits to your brand. In the previous chapter we looked at the measurable returns from using video, but some of the benefits of a great video are intangible. Let's have a look at these.

HUMANISATION

A video can put a face to a faceless brand. And I mean this quite literally. When we started livestreaming for Australia's largest appliance online retailer the response from customers was overwhelming! It turned out Appliances Online had a *huge* following on Facebook, but they only ever really interacted with their customers via text. The only client facing–people of this huge

company were the delivery drivers. And a lot of them were contractors!

We began a livestreaming video strategy that included going around the office and warehouses introducing workers to the customers. For the company's birthday we livestreamed a few product giveaways. I cannot overstate how blown away we were by the reaction from our customers. The majority stated that they couldn't believe how many people were behind the company – they didn't realise that actual humans (and so many of them) made the delivery of their washing machine possible!

In terms of the product giveaways, we had thousands of people emailing us daily to try to win products. We developed a cult following that week. People were tuning in at 11 am every day to watch us. They had bonded with Katie and me (we were presenting), but more importantly they had bonded and built an affection with Appliances Online.

Video allowed us to generate meaningful conversations too. One of our livestreams included placing a BBQ in the middle of a well-known Sydney location. The first to find it and say the magic word to camera would win it. The post exploded on Facebook. People shouting (a lot of exclamation marks were used!) and tagging their friends telling them it was round the block from them. People responding that their boss would kill them if they left the office! It was a bit of a hectic timeline of posts – but one thing it showed was that the video connected.

This sort of connection is invaluable. People buy from people, and can relate to other human beings a lot better than relating to a brand. In the above examples they were connecting with us

(the presenters) but in the knowledge that we were representing Appliances Online. Unless you are Apple, Nike or Virgin, you need to work hard to generate that brand affinity.

Video can lift your brand from being just a logo on a page or screen to a human being communicating to your customers, and if you're doing that correctly then you're half way to making a sale.

EMOTION

In making this connection you elicit emotions. And as discussed in the first few chapters (we're completing the full circle here!), emotion is what drives people. Emotion is what is going to make people make decisions. Harnessing this emotion is going to make your business money.

Think about famous vloggers like Casey Neistat, Gary Vaynerchuk or up-and-coming vloggers like Glen Carlson and James Wedmore. They make you feel good. They stir up emotions in you by relating to common problems we all have, and then they validate your way of thinking. It's almost a cult-like following they get from you – and they wouldn't have been able to elicit these feelings without video. There's just something about text and images that isn't as powerful as a full-blown video rant!

TRUST

The reason those influencers receive this God-like treatment is they have built trust. Trust is virtually impossible to gain via writing and images only (unless your Nigerian uncle has died and left

you his estate of $22.7 million – in which case we'll all throw our bank details that way).

But – you can probably tell where I'm going with this – trust is very easy to harness via video. This is because our limbic brain is stimulated more *and* picks up on more signals, to give us that gut feel of whether we trust someone or not.

We buy into products and people because we trust them. And to emphasise this point, I will leave you with a personal story that happened to me only last week, which kept me up over a couple of nights because I was trying to understand the purchasing behaviour of a client who had just signed up to a big-money deal.

I had met this future-client through a networking event and we connected on LinkedIn. A few months had gone by since our initial introduction. In that time we had one initial meeting to discuss a potential partnership, a couple of phone calls, and I had sent him a proposal. We had arranged this second meeting for a Friday at 4 pm, to go over the details of this year-long partnership. A couple of hours before the meeting, I was going through a selling framework I was trying to memorise so that I could take him through it in our meeting. I knew this was an important deal for my business, and I had to very clearly articulate his company's pain points and how emotion, trust, and engagement through videos would solve them for him. I was well and truly in full sales mode, going over the value that video would bring his company, when – half an hour before the meeting – I got a notification that he had signed the contract on the proposal I had sent! *Before* our meeting!

I was shocked. Part of me was frustrated that I had wasted the last two hours as he'd already been sold, but mostly I was delighted as it was a big partnership!

Our meeting went very well, but I was still up that night thinking how on earth I managed to seal the deal *before* the meeting that was meant to seal the deal.

Then slowly I started to recall interactions we'd had over the last few months. My new client had sent me texts about how much he loved my signature video on my email, had liked all my videos on Facebook, had commented on most of the videos I'd put up on LinkedIn, and had referenced on many occasions how well I came across on video.

It was then that I realised the power of building trust through video *for my own brand*. I had been so submerged in doing it for other brands that I never had a minute to think about the impact my own videos were having on future clients. My new client had spent months consuming a lot (if not all) of the video content I had been putting on my social channels. By putting videos out on social media I had been perpetually talking to strangers. These chats had led to engagement with leads. And, more importantly, it built trust between me and those people – ultimately turning them from strangers to customers.

And that's what I want every brand to achieve. The ability to leverage video in their business so that they too can perpetually connect, engage and inspire their customers to go on a journey with them.

Welcome to the Age of Emotion.

14. THE FUTURE OF VIDEO

Video. It is ubiquitous on the internet, and it's here to stay. Businesses need it to stay relevant and competitive. It is also getting more disposable; so how do companies tackle that?

Well, luckily the video industry is giving you a massive helping hand, in part through the advancement of affordable high-quality equipment, and in part through the ease with which platforms such as Facebook are enabling you to use video to communicate. It is also evident that the cost of hiring video production professionals is also coming down.

Let's start with DIY video. I hope this book has given you some handy tips on how to embark down that path on your own. Every business owner has a good enough camera in their company – modern smartphones are more than capable. It's all about taking the leap and starting to produce good content. And I think therein

lies the future of video. It's all about good content. If you think back to the beginning of last century, words (specifically books and newspapers) were the way in which people conveyed their messages to the masses. Video has now taken over.

From a technical side of things, I think we're going to be seeing a shift to more vertical video from an online perspective. This is already evident in the way the majority of us consume video on our smartphones, and companies such as Instagram are quickly changing the status quo to fit with this. If you have a DSLR camera and want to film for Instagram then I suggest you start experimenting by filming with it at a 90-degree angle. This will mean you will be filming as the video is going to be exported, making it look much better and not cropping out detail that you may need! Facebook's current stance on the best practice for video size (be it square, vertical or horizontal) is also to experiment to see what suits you or your business most.

If you don't have the time or the inclination to set up a DIY operation then I predict an even bigger reduction in price from traditional production companies. Bespoke filming of your offering is something that will always have to be done on location, but companies are circumventing that problem by using stock footage that can be more conceptual than literal. There will always be a market for high-end productions. However, this space too is getting more affordable. I predict that many medium-sized creative agencies will disappear as customers bypass the 'creativity' they bring by simply employing video companies that help them with their story and the emotive ways to connect. And therein lies the future of video: story, emotion and connectivity.

To see whether this book stands the test of time, I'll leave you with some of my predictions for video production in the next 20 years. Let's see how right or wrong I am! My predictions are:

- Vertical video will become the norm across online video.

- High-quality home and business videos will be produced in seconds, in an app, with a few clicks of a button.

- Virtual reality video will not be as big as predicted in 2018 (controversial, I know!).

- Editors will be replaced by artificial intelligence robots.

- 4k will replace HD resolution as the norm for online content from the mid 2020s.

- One-minute videos will be the norm for online content.

There's nothing new or groundbreaking about telling stories. We've been doing it for thousands of years. And the truth is that technology is getting so good that you only need a Joe Bloggs with a decent phone or camera to produce something that looks good. But if that good-looking production doesn't connect with its viewer, it's dead in the water! It's all about the story, the message, the connection, the emotion. Get creative and start engaging with your customers, human to human, through video. There's no better way to do it!

Lastly, I would like to welcome you all again to the Age of Emotion – now go out there and connect with your customers! 😊

CONTACT MICHAEL LANGDON

@iammlangdon

@itsmikelangdon

@iammlangdon

@iammlangdon

Michael Langdon

www.ingramcontent.com/pod-product-compliance
Lightning Source LLC
Chambersburg PA
CBHW071648210326
41597CB00017B/2152